Organized by Jane M. Farmer for
The World Print Council
San Francisco, California

Major funding provided by
Champion International Corporation
and The National Endowment for the Arts,
a federal agency.

International Tour sponsored by the United
States International Communications
Agency.

The World Print Council is a non-profit organization serving the international community of artists, collectors, and all those interested in printmaking and the arts. Located in San Francisco at Fort Mason Center, the Council is a resource and communication center whose goals are to enhance opportunities for artists; to increase the understanding and appreciation of prints; and to provide artists with a professional information service.

The World Print Council provides a variety of programs and services. The Council's program includes monthly exhibitions in the World Print Gallery as well as special exhibitions including the open juried triennial World Print Competition. The Council organizes conferences including "Paper Art and Technology," "New Print (making) Technologies," and the Western program for the "International Hand Papermakers Conference, Kyoto, 1983." The Council also operates a Slide Referral Service and publishes *PrintNews*, a bi-monthly digest of information and resources, as well as exhibition catalogues and books.

The World Print Council is a membership organization creating a cooperative community among peoples of the world. World Print welcomes your comments, suggestions, and participation. For more information please write: World Print Council, Fort Mason Center, San Francisco, California 94123.

Copyright © 1982,
World Print Council, all rights reserved.
Library of Congress Cataloging In
Publication Data
Main entry under title:
New American Paperworks
Library of Congress Catalog Card # 82-50195
ISBN 0-9602496-1-3

Book design: James Miho
Produced by Champion International Corporation

Front Cover Credit
Bilgé Friedlaender
Notes on River/House/Book, 1981.
Checklist no. 20
Back Cover Credit
Winifred Lutz
Dayfinder #3, 1981.
Checklist no. 33

Photographic credits

Sally Bruce: back cover, page 32.
M. Lee Fatheree: page 24.
Ke Francis: page 31.
Roger Gass: page 40.
Coleen Goltz: poster.
Bob Nugent: page 25.
Charles Rumph: front cover, pages 23, 26, 27, 28, 29, 30, 33, 34, 35, 36, 37, 38, 41, 42.
Bill Swensen: page 39.

Table of Contents

New　American　Paperworks

Artists represented in the exhibition

Neda Al-Hilali
Suzanne Anker
Don Farnsworth
Ke Francis
Sam Francis
Helen Frederick
Bilgé Friedlaender
Nancy Genn
Caroline Greenwald
Charles Hilger
Charles Christopher Hill
Winifred Lutz
Kenneth Noland
Bob Nugent
Robert Rauschenberg
Steven Sorman
Cynthia Starkweather-Nelson
Michelle Stuart
Sirpa Yarmolinsky
Joseph Zirker

Exhibition Advisors

Rand Castile
Director
The Japan House Gallery
New York City, New York

Alan Fern
Director for Special Collections
Library of Congress
Washington, D.C.

Trisha Garlock
Founding Director
World Print Council
San Francisco, California

Harry Lowe
Acting Director
National Museum of American Art
Smithsonian Institution
Washington, D.C.

Richard Murray
Director
Birmingham Museum of Art
Birmingham, Alabama

William Robinson
Director
Sarah Campbell Blaffer Gallery
University of Houston
Houston, Texas

Exhibition Schedule

Sarah Campbell Blaffer Gallery
University of Houston
Houston, Texas
June 11 – July 18, 1982

Birmingham Museum of Art
Birmingham, Alabama
September 19 – October 30, 1982

National Museum of Modern Art
Kyoto, Japan

The Shukosha Art Gallery
Fukuoka, Japan

The Fine Arts Center of Korean Culture
and Arts Foundation
Seoul, The Republic of Korea

Exhibition Hall
Central Library, Kiemyung University
Taegu, The Republic of Korea

Hong Kong Museum of Art
Hong Kong

The Metropolitan Museum
Manila, The Philippines

National Museum
Republic of Singapore

Foreword

Paper as a medium for artistic expression has reached a new level of sophistication in American art. In the past decade, a "paper renaissance" has swept the country. Papermaking programs have been introduced into nearly every college and university art department. Fine arts presses and publishers have also added facilities or provided access to them. Many small mills for producing paper by hand have been established, and a new breed of master craftsman has been born.

Artists, who have always been receptive to paper as a surface for conveying ideas and images, were at once drawn to these new resources. The result has been a metamorphosis. Paper has been transformed from a recipient surface to an integral part of a work of art. After 2,000 years, paper has become a new form of artistic expression.

It is this new artistic vocabulary, combined with rekindled interest in Eastern and Western papermaking traditions and the historical uses of paper in various cultures, that inspired *New American Paperworks*. It has been nearly five years since Jane Farmer first shared her dream for this exhibition with me. Neither of us anticipated that it would take five years to bring about; but those years have been extremely important in the development and refinement of the use of paper, which has become an established facet of contemporary painting, sculpture, and mixed media in the United States.

Although innovative use of paper is a common characteristic of the twenty artists selected to participate in this exhibition, each approaches his or her art and uses paper in a uniquely personal way. The works represented here include three-dimensional and flat pieces, simple pieces and constructions, pure and colored imagery, works rendered solely of paper and works incorporating other media and objects, combinations of Eastern and Western papers and processes, environments, and installations.

In her superb essay, Jane traces the philosophical and technological history of paper from its earliest precursors through its discovery in China, its refinement in Japan, and its westward migration to Europe. Her brief summary of the history of American art since World War II provides valuable insight into the appeal of handmade papers to our present generation of thoughtful artists and craftsmen, an appeal which has repeatedly asserted itself in diverse Eastern and Western cultures throughout thousands of years of human history. The essay points out what the objects in this exhibition demonstrate: that even in high-technology, paper-glutted, twentieth-century civilizations, the material explorations of art can rediscover the elusive spirituality that seems to be the essence of malleable natural fiber papers.

New American Paperworks will give Americans an excellent opportunity to examine the full range of effects being achieved with paper today. Through the assistance of the International Communications Agency, the exhibition will travel to Japan, where hand papermaking has been a revered art form for centuries, and then to Korea, Hong Kong, the Philippines, and Singapore. Many of the artists will travel with the exhibition to the Far East, where they may experience Eastern culture first hand. Artists of the Far East will be exposed to this contemporary American art as well as to the concepts and techniques examined in related lectures and demonstrations. The experience will culminate in an international handmade paper conference to be held in Kyoto in 1983.

It is particularly appropriate that the World Print Council, whose goal is to bring the world into closer communication, participated in the organization of this exhibition. The histories of communication, paper, and prints are intricately intertwined. It was this relationship, along with the growing interest in paper on the part of artists, that led World Print to organize the international conference "Paper—Art and Technology," to publish a book by the same name, and to pursue the subject in numerous *PrintNews* articles. *New American Paperworks* allows the World Print Council to explore yet another facet of paper, contemporary art, and international communication.

It goes without saying that an exhibition of this magnitude can only be achieved through the work and cooperation of many individuals and organizations. First and foremost, the credit for this exhibition goes to Jane Farmer whose unending enthusiasm, dedication and long hours of hard work have made this exhibition a reality. The professionalism and good will of the participating organizations have also made *New American Paperworks* a model example of public and private support of the arts. This complicated cooperative effort will enable many persons in the United States and abroad to benefit from the project.

Through their investigations of the aesthetic and conceptual possibilities of paper, the artists in this exhibition have expressed their personal philosophy and innermost vision. Through her essay, Jane has revealed the historical, spiritual, and physical wonder of paper. Each of you who sees the exhibition must examine this ancient and modern art form through your own eyes as well as with your own cultural and aesthetic background. We hope you will leave with a better understanding of paper as a medium, of Eastern and Western paper traditions, and of contemporary art. We hope it will be a rich and illuminating experience.

Trisha Garlock
Founding Director
World Print Council

Acknowledgements

To say that *New American Paperworks* has been a long time in coming is an understatement. That there is an exhibition, and one of such a complex scale, is a tribute to the hard work and patience of *many* people. Usually reserved for last in such tributory pages, I would first like to thank my husband Don—a constant source of support—and my children, Christa and Matthew, who have all permitted paper to invade their lives and who now know more about handmade paper than they ever thought they might!

I am indebted to the exhibition advisors who have continued to be supportive over the long term: most notably to the late Joshua C. Taylor, former advisor and mentor. I am also grateful to the other advisors: Rand Castile, Alan Fern, Trisha Garlock, Harry Lowe, Richard Murray, and Bill Robinson. Geography has prevented our meeting together, but each has been very helpful in his/her own area.

Particular thanks go to the World Print Council, especially to Trisha Garlock. Her long-distance counsel has been invaluable and her cheery optimism has picked up many a late evening. Leslie Luebbers and all of the other staff members have been terrific as well.

At Champion International Corporation there is another long list of people who have helped. Andrew C. Sigler, Chairman, provided much-needed early support for the exhibition. And I am also obliged to David R. Brown, Marian Jill Sendor, Sallie B. Vandervort, and all the others who have helped make the exhibition and particularly the catalogue a reality.

At the National Endowment for the Arts, Kathleen Bannon, Director of the International Program; Tom Freudenheim, Director of Museum Programs; and particularly Steve Rogers deserve a volume of thanks for their support of the exhibition. At the United States International Communications Agency there are many on Ed McBride's Arts America staff who have been helpful: Wendy Beaver early in the project and, since her departure, Anita Banks have carried out the many day-to-day tasks with unfailing good humor. John Daly, Meredith Palmer, John Coppola, and Ed Ifshin have each been most helpful as well.

Bill Robinson and his staff at the Sarah Campbell Blaffer Gallery have already been terrific and we have just begun our work together! And thanks go to Richard Murray, an early supporter, and to those at the Birmingham Museum of Art with whom we will be working next fall.

This catalogue is also the work of many. Jim Miho brought more than his excellent skills as a designer to the task—he also has a special sensitivity to handmade paper and is extremely knowledgeable about its history. Charles Rumph was a joy to work with on the photography. All our readers will benefit from Timothy Barrett's willingness to share his extensive technical knowledge about the making of Western and Eastern papers. The glossary was the hard work of Trisha Garlock, with input from Asao Shimura and Don Farnsworth. The catalogue's final form is the product of the untiring and excellent editing skills of Carole Jacobs.

Beyond the particular roles in the organization of *New American Paperworks,* several people served as sounding boards for the exhibition, and particularly for the catalogue essay. Lane Katz, former economic correspondent on Japan; Louise Cort, curator at the Freer Gallery; Sachiko Usui, program officer at the American Center in Kyoto; Seishi Machida, Professor Emeritus, Kyoto Technical University; Asao Shimura, paper historian, Kasama, Japan; and artists Bilgé Friedlaender and Winifred Lutz have all listened patiently and given much of their substantial expertise, for which I am most grateful. Ji-xing Pan from Peking very kindly shared his fascinating research with me during a visit to Washington. Asao gets a special "thank you" for his organization of the 1981 Washi Tour to Japan. It was my first trip to Japan and provided a rare memorable introduction to a culture and a people. And my thanks are also gratefully extended to the many papermakers in the United States and Japan who have welcomed me into their paper shops and shared their knowledge with me. Thanks go as well to the dealers who have helped on this exhibition: Susan Caldwell, Susan Caldwell Gallery, New York; Barbara Fendrick, Fendrick Gallery, Washington, D.C.; Helen Getler, Getler/Pall Gallery, New York; Jean Milant, Cirrus Gallery, Los Angeles; Bonnie Sussman, Peter M. David Gallery, Minneapolis; Ann Tullis, Institute of Experimental Printmaking, San Francisco; and Joanie Weyl, Gemini, Los Angeles. I am indebted to Joseph Saunders and Jim Ikena—both calm patient souls —who made the production end of the exhibition a pleasure.

Last, but certainly *not* least, I want to thank all twenty of the artists represented in the exhibition. It is their work which inspired the exhibition and their friendship and enthusiasm which has made it such a pleasure to work on this project.

Jane M. Farmer
Curator/Project Director
March, 1982

Paper: The Technological and Spiritual Wonder of the Ancient World

Jane M. Farmer

The material (paper) is beautiful and precious,
Though cost is cheap yet quality is high…
Stretching out when it opens and rolling up
 when put away,
Able to contract or expand, hide or expose…
To convey your affection to a distance of ten
 thousand miles away,
With your refined thought written at one corner.
Fu Hsien (234-294 AD)[1]

Today all of the civilized world takes paper for granted as an everyday fact and necessity of life. At the time of its development in China, however, paper was nothing short of a miracle. Indeed from the very outset of its use, the Chinese valued paper as much for its intrinsic aesthetic and spiritual properties as for its utility in communication and the storage of information.

True paper is generally defined as a tissue of any fibrous material whose individual fibers, first separated by mechanical action, are then suspended in water and collected on a porous mould. For true paper the fibers must be hydrated (beaten in water so that the fibers retain a certain amount of water) and physically pressed sufficiently for hydrogen bonds to form between the cellulose fibers. The result is a durable and lasting sheet that retains its original character despite additional soakings and/or manipulations.[2] Many different fibers have been used, many variations have developed for each stage of the process, and as many types of paper have emerged as there are processes. The visual effects of the papers produced by the two major techniques, the Japanese technique of *nagashizuki* and the Western technique of *tamezuki,* are as different as the processes which create them.[3] It is these visual differences and their cultural uses that one must explore to better understand the use of paper as an aesthetic medium which is so prevalent in the United States today. With respect to the attitudes any given culture has towards paper, the timing of its introduction is as important as either the technical or visual differences.

Ancient Precursors to Paper

Human beings have devised graphic symbols and found surfaces upon which to inscribe them from the earliest time, but early writing surfaces—bones, stone and clay tablets, and wax-covered wood tablets—were all very time-consuming to prepare and bulky to transport and store.

Communication and record-keeping were, of necessity, difficult and costly. Hence many civilizations sought to develop a lighter, less expensive medium of written communication. The history of paper, its forerunners, and the processes for making them throughout the world is well-documented. It provides telling evidence of the complex interrelations between the uses of quasi-papers and ultimately of true paper in various cultures and the intellectual development of those civilizations.

Understanding the cultural uses of paper requires understanding the uses of many of the precursors of true paper. Papyrus, laminated strips of the papyrus plant, originated in Egypt over 4,000 years ago and was exported throughout the Mediterranean area. The process for the preparation of papyrus remained in Egyptian control, however, making it costly for other cultures to obtain. As alternatives to expensive, imported papyrus, the Persians developed vellum—scraped and treated calf skin—and parchment—the inner layer of split sheepskin, also scraped and treated. In the Mediterranean these precursors to true paper were used primarily for communication and record-keeping. They were viewed as flexible surfaces which could preserve information—be it pictographs, words, or visual images—in various types of scrolls, codices and other book forms. The emphasis was on the utility of these surfaces, and the materials themselves were not felt to have any particular spiritual significance.

For other civilizations the alternatives to paper had both functional and spiritual uses. Various forms of *tapa,* a substance made by pounding bark from the Chinese paper mulberry (Broussonetia Papyrifera) and related trees from the mulberry family were used throughout the Pacific, including Hawaii; Central, South, and northwest North America; Polynesia; New Guinea; Java; Melanesia; the Malay Peninsula; China; the west coast of Africa; and Japan.[4] In ancient Hawaii, tapa was used for clothing, bedding, bandages, burial wrappings, lampwicks, threads, blindfolds, and kites. It was also used for culturally significant gifts—a child's dowry, a gift for the owners of a new home or parents of a first-born son—and for tributes (taxes) for chiefs. In addition tapa was used as an offering to the gods when someone was ill or had died, and white tapa was used as ceremonial drapes for temple images and ceremonial staffs. Plaited mats of tapa strips were used in seances for communicating with the dead and in *kuni,* ceremonies to reveal and

punish a person who prayed another to death.

For ancient Hawaiians tapa also had other magical effects—it was worn as a charm to induce the flow of milk in a nursing mother, used as a banner for gods, and fashioned into a special oven for preparing an ill or dying person's food. Tapamakers honored four gods: *Maikoha,* the family god for tapamakers; *Lauhuki,* Maikoha's daughter, who imparted skill and wisdom to her believers; *La'hana,* Maikoha's other daughter, who introduced the use of bamboo sticks; and *Ehu,* the god of dye experts.[5]

Across the Pacific the ancient Mayans of Central America developed *huun,* their own version of pounded inner bark material similar to tapa. This more supple and far less cumbersome surface replaced stone monoliths for their hieroglyphic writings and sophisticated mathematical and calendar systems. Pieces of huun, removed from the tree in a single sheet, were often as long as 15 feet. The Mayans made folded books—some of them up to 34 feet long—which were scribed by the astronomer priests and stored in sacred stone buildings. When the Toltec people surpassed the Mayans in the seventh century A.D., they assimilated the huun process and continued to improve it.

The inheritors of all of the technical developments made by the Mayans and Toltecs were the Aztecs, who established themselves in the area of present-day Mexico City. The Aztecs' domination over the other tribes depended upon their exacting considerable tribute from the tribes they had conquered. Their extensive record-keeping indicates that much of the required tribute was in the form of *amatl,* the Aztec version of huun, which was central to their religious practices. The Aztecs continued to refine the process of making amatl from various indigenous ficus (fig) trees, which are in the same botanical family as the mulberry trees used for papermaking in the Orient. The Aztec books, *tonalamatls,* illustrated with a complicated system of pictographs, assumed increasingly elaborate forms. Paper—the medium for all of the cumulative sophisticated culture developed by the civilizations of Central America—became a major key to Aztec culture.

As a space-saver, a time-saver, a labor-saver, and so, ultimately a life-saver, paper had a unique part to play.…Yet the Aztecs had an even more profound paper world [than industrializing Europe], for with them paper was, in addition, ceremonial.…The chief

function of paper was to placate the gods and to record, preserve and implement the power of the rulers. It was only after these high needs were filled that the residue of paper would reach the populace, and this residue, used by each individual in hundreds of rituals varying from month to month and almost from day to day, would bind him to throne and temple in a great unity of paper tradition and symbolism.[6]

The form of Aztec ceremonial paper ranged from paper flowers worn on the robes of high priests and by dancers celebrating particular gods' days, to draperies of significant colors placed over persons — often children — to be sacrificed to the gods, to paper banners up to 60 feet long and raised on tall poles in citizens' courtyards to honor gods, to paper substitutes for real objects, such as paper pouches painted to look like tiger skin worn by minor priests in imitation of the real tiger pouches worn by the high priests. Paper clothes, paper hair, paper strips on poles, paper masks, paper awnings, paper sacrifices burnt on individual home hearths to thank gods who warded off illness — all were important and gave the common person a part in the ritualistic society.

The Aztecs had specific roles for various forms of paper in the preparation of the dead. The corpse, dressed in particular papers, was provided with paper flags attached to sticks and paper passports that would allow his spirit to survive the dangers of the mythical creatures and demons it would encounter on its way to *Mictlan*, the Aztec land of the dead. Upon reaching this land of the dead, the spirit presented its various papers and was allowed to stop its wandering and rest in peace.[7]

To this day the production and use of traditional amatl continues among the Otomi Indians of San Pablito and several other remote villages which have produced amatl since ancient times. Because centuries of Catholicism and modern mores have diluted the ancient Aztec religion, these ceremonies are now described by the Otomi themselves as "customs" and performed by the local witch doctor. Nonetheless, many of the present practices among the Otomi are directly descended from rituals performed for centuries for the many Aztec gods. To this day these observances center around the gods who bring rain, good crops, good health, and fertility. Often the modern version calls for a more obvious tribute to the contemporary practitioner in the form of tamales or a chicken cooked in a cake and wrapped in paper, which are eaten by the witch doctor as part of the ceremony. Having

replaced the human sacrifices of old, paper is even more central to these rituals now than it was to their forerunners.

The Otomi's *muñecos*, cut paper figures representing various spirits and believed to possess the nature of these spirits, are important in these contemporary versions of the ancient rituals. Muñecos can be benevolent — the Sentinel Door Guards who protect households, seed figures that insure good crops, and the Spirit of the Lion which is buried with a corpse to see the departed spirit's needs and protect it from unfriendly beasts in the Land of the Dead — or malevolent. Generally black papers are used to represent evil spirits or to bring evil to the persons they represent and lighter or white papers are used to represent good spirits or persons. A witch doctor explains the efficacy of these figures in the following way:

"As the figures representing the various spirits, personages or animals have the power of speaking and acting amongst themselves, just as if they were living beings, when an evil spirit, either a demon or any other, attempts to enter a house where a ceremony is taking place, when it reaches the door "The Otomi Man" says to it: 'It is forbidden to enter, you cannot go in; go away.' If it does not depart, they [the several door sentinels] seize it amongst them all and eject it forcibly, shutting it up in the cave from which it will find it hard to escape..."[8]

A contemporary Otomi ceremony performed to "pay" for the things one receives in daily life — land, food, wood, etc. — involves the making of a sacred framework of bound sticks that holds a paper platform on which the symbolic Otomi muñecos are placed. The witch doctor, to the music of violins and guitars, decapitates a chicken — dripping its blood on the paper. A procession of musicians and participants led by the witch doctor then bear the framework and corpse of the chicken to the plot to be sanctified, where the offering is buried and covered with pieces of straw tied to represent the stars.[9] Perhaps the downfall of the Aztecs was related to their inability to substitute such surrogates for their literal and violent sacrifices and rituals. Still one marvels at the powerful symbolic role that amatl paper played in this ritualistic culture. Without having ever arrived at a technique for the making of "true paper," the Aztecs had sensed the functional as well as the aesthetic/spiritual nature of amatl and had developed it to a very sophisticated level. Further research will hopefully reveal the relationships

among the many geographically scattered Pacific cultures that used pounded mulberry bark material in such similar ways.

The Dual Role of Paper in the East

In China the precursor to true paper was woven silk, which was often dipped in gum and polished to create a smooth surface[10] and could be rolled into scrolls. The development of the hair writing brush facilitated writing with ink on the flexible silk. As a system for record-keeping, communication, and the making of images this was a major improvement over the earlier use of the bamboo and wood writing surfaces. Woven silk was labor-intensive and much in demand for clothing, however, and the Chinese had begun to experiment with less expensive substitutes by as early as the second century B.C. Archaeological research and analysis of ancient samples continue to illuminate the history of the beginnings of true paper. Because half of the Chinese character for paper is the same as that for silk, historians have theorized that a quasi-paper using silk fibers predated true paper's development in China. According to the most recent research by Ji-xing Pan of Peking's Institute of History and Natural Science, however, silk was never used as a papermaking material. Pan's microscopic analysis of ancient papers found in Bagiao, Labnor, Jin-quan, and Zhong-yan (respectively dated 140-87 B.C., 49 B.C., 52 and 6 B.C., and 73-49 B.C.) prove that they are all made of hemp and ramie fibers and contain no silk fibers. The length and purity of the fibers indicate that they had been artificially shortened (beaten), fibrillated, and purified to remove non-cellulose materials. The most recent paper, from Zhong-yan (dated 73-49 B.C.), shows the pattern of a laid mould.[11]

These findings invalidate the traditional date for the "invention" of paper, 105 A.D., and indicate that the Chinese bureaucrat Ts'ai Lun, who is usually credited with the invention of true paper, was more likely the first person to sponsor its acceptance by the Emperor Ho and to promote and oversee the establishment of the official production of paper for the court. Once officially accepted and produced, true paper was adopted quickly throughout China. The recipe for papermaking remained a closely guarded secret throughout the long period when China controlled the Central Asian basin of the Tarim River and thus the heavily traveled silk routes.

The era during which paper was developed in China, the Han dynasty, was a time of philosophical change and

re-orientation. Confucianism and Taoism had absorbed the family-oriented pantheistic and ritualistic folk religions and had become the predominant religions of China. The Chinese had traditionally emphasized their own history and continuity from the past to the present. Indeed, their word for *gods*, literally translated from the Chinese word *ti*, meant *first ancestors*.[12] Writing has held a crucial position in Chinese culture since the earliest characters were incised on bones; it has been important both for authenticating the historic record and for communicating with the gods. Although animal sacrifices and offerings were also made to the ancient ancestor gods, written communication was of primary importance. Confucianism had imposed an ethical and structured focus on the earlier philosophy without eradicating it. The Taoists, in their own way, had absorbed the mysticism of the earlier shamanism. Although the Confucian and Taoist points of view often came into political conflict, both not only allowed but encouraged the continuation of ritual and a reverence for ancestors and spirits. Paper's flexible nature, seemingly magical formation, and low cost were timely for this culture which valued both the recording of history and communication with its revered ancestral deities.

The introduction of Indian Buddhism in the third century A.D. did not extinguish the Chinese symbolic and ceremonial uses of paper. Over the years these traditions were incorporated into the Mahayana sect of Buddhism which predominated in China. Buddhism had heightened the already intensive Chinese concern with the afterlife and ancestor worship. Therefore at a time when sacrifices and the burial of coins and actual objects with the dead (for their use in the afterlife) were giving way to symbolic substitution, paper provided the perfect sacred substance.

The elaborate system of ritualistic and ceremonial use of paper has evolved over the past two thousand years in China to serve many everyday and philosophical needs. Paper took on the household and everyday role that icons and religious art fulfilled in the temples. The continued domination of the family and family-based religious ritual over mass worship accounted for the strength of paper as a symbolic and sacred substance. In the resulting "paper world" a pantheon of *ma chong*, or images printed on inexpensive paper, represented all manner of gods from minor to important. Among those represented in the home were Buddhist gods such as the Goddess of

Mercy and Taoist gods such as the Door Guards, the Kitchen God (the most common in the China of 1927 visited by Clarence Burton Day), the Water God, the Fire God, the Five Gods of the Silkworm, the Two Genii of Peace and Harmony, the God of Wealth, the God of Literature, the God of Anything You Wish, and the Green Dragon Protector. These paper gods were typically pasted on exterior or interior walls in positions which facilitated their protection of their respective interests in the household. Different regions and different households featured different gods, according to their traditional needs. Generally the paper gods were taken down and ceremoniously burned at the appropriate time each year. For example, the Kitchen God was burned in a hearth ceremony prior to the New Year and, as smoke, ascended to the Pearly Emperor of all the gods, to whom he reported on the family's conduct for the past year. To insure a good report, he was first presented (and sometimes literally smeared) with honey, sweet cakes, and sweetened rice to seal his lips about whatever quarreling and minor infractions had been committed by the family that year. After the appropriate period of time without a Kitchen God—while he reported to the Pearly Emperor—the family celebrated the New Year with a bounteous feast and welcomed him home. A new paper Kitchen God was then ceremoniously mounted on the wall.[13]

This pantheon of gods met several needs of the family which continued from ancient times through the present: the protection of life and property, adjustment to and protection from environmental forces, peace and harmony in home life, and success in the achievement of a livelihood. In addition, the various gods and ancestor spirits interceded in the salvation from a horrible hell and the attainment of virtue in heaven. The latter were comfortably accommodated to specific precepts of Confucianism, Taoism, Buddhism, or an amalgamation of all three.

Its efficacy as a charm or symbolic means of satisfying good and evil led to numerous other ceremonial uses of paper in China. Long paper banners and signs were placed over doorways and gates for the many ceremonial holidays and rituals. The colors of these banners, like those of greeting cards, gift wrappings, and documents of importance, were symbolic of different moods for particular occasions: red for joyous, happy, and important events; blue or black for death and sorrow; and white for purity. The emotional associations of these symbolic colors remained consistent in other cultures as well.

Perhaps the most elaborate use of symbolic paper was in the traditional Chinese funeral, where paper played a key role in orchestrating the many conflicting spirits as well as the many emotions of the participants. Hundreds of years of tradition dictated the precise use of paper in the preparation of the corpse, the rituals before and after burial or cremation to insure a safe journey for the dead's spirit, the announcement of the death, the adornment of the home of the deceased, the sympathetic response of friends and relatives—including the amount and quality of the spirit money they sent to honor the dead, and the decorum of the human and spiritual participants in the entire funerary process. Each aspect was dictated by ancient custom, and papers and paper objects were the guides for the various necessary rituals.[14]

The importance of tracing family and cultural ancestry and origins has made the Chinese careful and thorough historians. New philosophical and literary writings are often reinterpretations of ancient treatises. As the literal embodiment of its content, the written word determines the authenticity of a fact or idea. The visual arts place a similarly heavy emphasis on the reinterpretation of classical themes and this same reverence for the past predominates in the history of calligraphy and the evolution of written characters. The Chinese have always respected every scrap of paper, particularly those containing writing. Paper with visual images or writing on it was never crumpled up and thrown away when it had served its purpose as it is in Western society: it was ceremoniously burned. Elaborate rituals developed around the collection of scraps of paper, their ceremonial burning—often in sacred furnaces erected for that purpose in temple courtyards—and the respectful disposition of the ashes in a nearby body of water.[15] To be disrespectful to even a scrap of paper was to profane the thought or concept itself, thereby risking the wrath of its attending spirit. Although the worship of household gods and extensive funeral ceremonies are no longer common in China today, paper continues to have a strong role in the culture. The paper banners and decorations used today in holiday observances are closely related to those of ancient times.

This extreme reverence for paper as a special substance carried over to its use in religious and secular art. Particularly among Buddhists, paper was deemed an appropriately natural, sacred, and humble material for the copying of sutra and other religious documents. Paper became popular among some Chinese for secular

uses as well. Although immediately after the introduction of paper an individual might have been prone to apologize for sending a scroll on paper instead of silk, paper came to be used extensively for calligraphic scrolls, paintings and fine books, elaborate screens and fans, and many other objects created for aesthetic appeal. Paper met other functional needs as well: it was used to make padding for clothing (particularly encouraged because the use of animal fur was forbidden by Buddhism), toys, decorations, and firecrackers. Using paper for these objects was considered in no way irregular or blasphemous: the sacred role of paper only served to enhance its role as an aesthetic and utilitarian material.

The Spread of Paper East with Buddhism

The exact date that the knowledge of papermaking spread to Korea is not known, but it was certainly during the Han dynasty's conquest of the north-western province of Korea (then known as Choson) to gain control of the Uighur nomads to the north, in the second and third centuries A.D. The Chinese colonies became prosperous outposts of China and papermaking was introduced during this period, with Buddhism taking hold a short time later, in the fourth century. The indigenous Korean religion was animistic and ritualistic, serving gods who were very much tied to natural cycles and the concerns of an agrarian population. After the Koreans adopted Buddhism, Buddhist monks traveling back and forth from Korea to China and India established cross-cultural communication in all subjects, including Chinese papermaking technology.

The Koreans made some modifications of the papermaking process and Korean Buddhists developed their own sacred uses of paper, including the copying and later the printing of Chinese and Indian Buddhist texts. They also developed their own unique functional uses for paper, among them the use of oiled paper as a covering over mud floors which were heated from below by flues from an oven. Paper was also used for windows, as it was in some parts of northern China; for lacquered baskets woven of paper string; for lacquered paper chests; and for many other objects with functional, aesthetic, and spiritual uses.

The year 610 is commonly agreed upon as the date when a Korean monk introduced Chinese papermaking to Japan. There are some indications that Japan was already

using hemp and kozo — possibly for a pounded bark material like tapa/amatl.[15] Significantly the introduction of paper-making was concurrent with the Japanese acceptance of Buddhism. The Japanese were an aesthetically sensitive people whose own religion, *Shintoism*, was animistic in nature and placed a premium on ceremonial purity and ritual communi-cations with the many *kami*, or spirits. The introduction of paper to Japan occurred at a time when much of the culture of China was being eagerly absorbed by the Japanese. With its emphasis on the arts, historic record-keeping, and the written language, and its growing tradition of using paper as sacred material, Buddhism immediately created a great need for paper in Japan. Important improvements in the process for papermaking were developed almost immediately, using indigenous Japanese fibers, kozo and gampi. The strength, flexibility, and translucency of this Japanese paper compared quite favorably with the hemp-based paper produced by the Koreans and Chinese.

The Japanese Shinto faith, with its emphasis on purity, harmony with the natural world, and a positive focus for the present rather than a fear of evil and death, absorbed the more positive aspects of Chinese Buddhism, as well as Confucianism and Taoism. The result was a comfortable faith wherein goodness (purity and ritual) and beauty were one integral concept which infused every aspect of daily life. *Washi*, or Japanese handmade paper, is a natural substance whose production requires natural fibers and pure water from mountain areas; it quickly became a respected and popular product and was incorporated into many Shinto rituals of purification and cere-monies of major life events.

It was logical to add paper ornaments to the already traditional evergreens and *shimenawa*, or ropes with natural fibers, used to mark Shinto shrines in which the kami resided and particular places of celebrations. The *shide*, or folded paper ornaments hung from straw ropes to lure the kami to sacred spots and ceremonies and to demarcate the areas for Noh plays within shrines; the use of *gohei*, or sticks with folded and/or cut paper ornaments tied to them and used buy the Shinto priest in purification rites; and the cut paper *sanbo kogin*, or Shinto god of the hearth, are all ritual uses of paper in which its natural purity and ability to be replaced and renewed for each event are complementary to and consistent with the Japanese Shinto traditions. Thus this new material, paper, was integrated philosophically into Japanese Shinto ceremonial uses.

Within a century and a half after its introduction to Japan, Buddhism, with its paper-using tradition, had interacted with Shintoism, and from this period of rapid change emerged a strong beginning for Japan's unique version of Buddhism, in which much Shinto ritual and the new ceremonial substance, paper, were key ingredients. One of the earliest formal uses of paper as an act of piety and absolution was the commissioning by Empress Shōtoku in 770 A.D. of one million *dharani*, paper scrolls printed with sacred texts and rolled inside miniature three-story wooden pagodas, for distribution to the ten major Buddhist temples in the Nara area. These charms were made of several types of paper, including some kozo. These dharani, which are among the earliest examples of woodblock printing, document the level of sophistication and sanctity that washi had already achieved in Japan. The copying of *sutra*, or Buddhist sacred texts, became an important aspect of Buddhist piety. The act of copying was viewed as a form of meditation and the resulting sutra were considered sacred. An example of a Buddhist ceremonial use of washi is the *sange*, or lotus flower-shaped cut papers which contemporary Japanese Buddhists still use in lieu of the actual flowers Indian Buddhists used in the original form of this purification rite.

The *Omizutori* ceremony at the Todai-ji Temple in Nara demonstrates the 1200-year-old Buddhist use of *kamiko*, or paper cloth, for ceremonial purposes. Kamiko is thick kozo paper which has been treated with *konnyaku* or *kanten*, the former a polysaccharide from arum root and the latter a vegetable gelatin, and then wrinkled. Repeated treatments render the paper pliable, strong, and waterproof. From its development early in the history of washi, kamiko has been used for coats, robes, jackets, vests and other outerwear as well as for underwear. In the Omizutori ceremony, dating back to early Buddhist days in Japan,

Buddhist monks spend two weeks or more in heavy meditation, self-reflection, and ascetic training. During this period, each makes for himself a kimono out of undyed, handmade paper. The monk is required to rub, soften and waterproof the material for his own robe. Between February and March, at the coldest point of winter, the monks go into seclusion wearing only these robes, enduring austerities in the cold and snow. Smoke from burning incense sticks gradually blackens the kamiko garments; holes are worn into them where the monks' knees have rubbed through the paper in prayer and meditation. Then, when all the austerities have been completed, the priests return for the ceremony. At midnight the kamiko-robed monks proceed down the temple corridors, carrying lighted torches and

chanting prayers. In an open area of the compound the monks brandish these immense burning torches, making great circles of flaming light in the night air. Since the fire is believed by these Buddhists to be power against evil, worshipers pursue the flying sparks, certain that such magical flames burn nothing on which they land. Then the sacred water, believed to have flowed all the way from Wakasa in the north to Nara, is drawn from the well. At the end of the ceremonies the monks burn their white paper robes in a purging bonfire. Although the ceremony is Buddhist, it bears touches of Shinto in the sacred use of white paper— especially washi that has touched the body— in this rite of purification.[17]

The timing of paper's introduction to Japan, the Buddhist prohibition of the use of animal products, the limited number of alternative materials, and the special connotations inspired by paper's ritualistic role made paper the perfect material for many secular and functional uses as well. For example, paper was used for everyday clothing as well as for the kind of ceremonial garments described above. Thin sheets of gampi were cut into strips and woven into *shifu*, a woven paper fabric which was used for vests and coats because of its insulating qualities. Different weights of shifu—some with flax or silk wefts—were developed for more decorative garments, such as kimonos and obi sashes, and for many other clothing and functional uses.

The strength and translucency of washi inspired its adoption for additional functional and ceremonial uses of paper in Japan. Sliding *shoji* doors and windows allow diffused daylight to pass into traditional Japanese homes while providing privacy and a surprising amount of temperature insulation. The application of a new shoji-gami each year is an example of a practical task that also provides spiritual satisfaction akin to the ceremonial purification rites in Japanese Buddhist and Shinto worship. *Fusuma*, sliding panel doors, are also covered with special decorative washi such as the lovely *uchigumo*, or "cloud paper." Paper lanterns capitalize on the translucent qualities of washi for artificial light. Although these lanterns were popular practical items, they were also adapted to Shinto and Buddhist uses, including the Buddhist Bon Festival when hundreds of lanterns honor the kami of returning ancestors.

The role of paper in Japan—more than in any other contemporary culture—is a symbiosis of secular and spiritual traditions, and contemporary secular and ceremonial uses have grown out of this

intermingled past. Cut paper dolls originally used for the Shinto practice of exorcising illness and evil spirits—which sometimes included burning of the dolls are drinking the ashes with water—have evolved into a custom observed in Tottori prefecture during the Girls' Doll Festival in March, where groups of paper dolls are banded together with bamboo and floated down the river to free children from any problems for the coming year. Boys' Day in May is celebrated throughout Japan by the *koi-nobori*, or carp streamers hung out to symbolize the courage and manliness of the carp who fight their way upstream to spawn. Originally these jaunty streamers were made of paper; they are now as often made of cotton or synthetic fabrics.

All craft groups in Japan have patron *kami* or gods, and specific shrines are often devoted to them in areas with strong traditions in particular crafts. In the ancient province of Echizen, one of the oldest papermaking areas of Japan, there is a legend that describes the introduction of papermaking to the region by a kami who disguised himself as a maiden. The town of Imadate has a shrine with carved panels depicting this legend. Atop the peak behind Imadate is the Okamoto shrine, which includes a smaller sub-shrine, Otaki, the home of this paper goddess. On New Year's Day the paper-makers from the area climb to Otaki— regardless of the weather—to make gifts to the papermaking goddess for their protection during the coming year. The practice of hanging a small shrine in an out-of-the-way area of a papermaking workshop is still quite common through-out Japan.

The role of handmade paper is important in the fine arts, performing arts, and martial arts of Japan. Many of paper's roles in the fine arts come directly from the Chinese version of these artforms. For example, the beginnings of Japanese calligraphy, screens, fans, scroll paintings, and fine books can be traced to the strong influence of Chinese art and have developed in Japan from this source. The origins of woodblock printing as a fine art are evident in the earlier Chinese Buddhist and Taoist uses of seals and stamps for protective charms. Japan's further refinement of papermaking was a key factor facilitating the major Japanese contribution to the development of the woodblock print.

The role of paper in the demarcation of areas and purification of participants in the arts of *sumō* wrestling and *yabusame*, or traditional archery, and the perfor-mance of Noh is directly related to the origins of these arts as side entertainments

at Shinto festivals. Before the introduction of paper to Japan, pounded bark and then pure linen fabric were used for the consecration of these areas and events. Paper quite naturally assumed this role.

The integration of paper into the fine arts, architecture, ceremonies, and daily life; the remarkable conceptual unity of secular and spiritual uses of paper in Japan; and the purity with which the papermaking has been carried on in certain areas and families for generations, have forged a unique role for paper in the Japanese culture—one unmatched anywhere in the world. Recognition of the extra-ordinary role of washi and a concern for its survival—as well as that of similar crafts in Japan—have inspired the system of designating Intangible Cultural Properties, whereby the government honors the most skilled practitioners of traditional crafts and provides stipends to support the continuation of and further education in craftsmanship. It is hoped that this program will help preserve the tradition of crafts such as papermaking— and thus one descendent of the first true paper made in China.

The Westward Migration of Paper

During the seven centuries after its formal acceptance under the sponsorship of Ts'ai Lun, the process of papermaking was confined to China, its territories, Korea and Japan, where a series of technological improvements produced a paper far more sophisticated than the original Chinese hemp and rag paper. The widespread use of paper in China coincided with the increased traffic along the trade routes to the West and additional expansion to the northeast and south. Eventually papers of varying combinations of hemp (both raw and processed, as from old fish nets and ropes), rags, and the bast fibers of the mulberry tree were produced in different spheres of influence within the vast area of Asia which interacted and ultimately— in the thirteenth century—became the Mongol Empire. Examples found from the seventh and eighth centuries indicate that Southeast Asia and the areas along the northern Himalayas through Tibet and parts of Nepal were making paper with simple fabric moulds such as those originally developed in southwest China.[18] To the north, northeast, and northwest, a later mould with a removable bamboo or grass cover developed, allowing the removal of the paper from the mould when it was still wet, and thereby increased production. Improved methods of preparing the fibers and finishing the sheets also resulted in better surfaces for writing and printing. It was this later mould and papermaking technique that spread to Chinese Turkestan and to Korea

in the third century, and to India via Kashmir and the trading routes over the Khyber Pass in the eleventh century. Paper gradually replaced bamboo, palm leaves, and wood for record-keeping and religious manuscripts, and the papermaking processes were adapted to the materials available in the new areas. When the Arabs finally acquired knowledge of the process — by capturing prisoners who were papermakers, in Samarkand, in 751 — the process was well-developed.

So far as an invention can ever be said to be completed, it was a completed invention that was handed over to the Arabs at Samarkand. The papermaking taught by the Arabs to the Spaniards and Italians in the 13th century was almost exactly as they had learned it in the eighth. The paper used by the first printers of Europe differed very slightly from that used by the first Chinese block printers five centuries or more before.[19]

By 751 A.D., the twin roles of paper had become firmly established throughout China but they sometimes interfered with one another. For example, the adoption of paper as an economical medium for publishing *authentic* classical documents of Chinese history and literature such as Teng Tao's edition of the Confucian Classics was slower than it might have been — perhaps in part because of paper's other, stronger role as a religious ritualistic substance.

Considering that Central Asia was in the first seven centuries populated by an incredible mix of races, tongues, cultures, and faiths, the disparate peoples made amazingly similar uses of paper. Findings at Tun-huang, Kharakhoto, Turfan, and in Egypt early in this century shed new light on historic accounts of the role of paper and printing in Central Asia, demonstrating that whole aspects of the use of paper had not been recorded — probably because they were associated with Buddhist and Taoist ritualistic religious practices and therefore were not deemed significant by the Confucian-oriented historians. For example, votive prints, charms, amulets, playing cards, ritualistic paper materials, and sacrificial papers played an important part in the everyday lives of the peoples of this era and contributed significantly to the rapid spread of papermaking and printing in the form of stamps, seals, and — ultimately — woodblock printing throughout Asia. Buddhism and its various sects adapted these rituals, and the Buddhist emphasis on manuscripts and the copying of sutra and other religious passages as acts of atonement for the dead and for the living, was an important motivation in the use of paper and multiple images such as woodblock

prints. On one hand, the vast amount of paper used for Buddhist literature confined paper's role in the writing and printing of more general literature; on the other hand, the same extensive body of Buddhist literature spurred the acceptance of printing on paper for more secular uses.

The remnants of these paper uses as revealed by the archaeological work of expeditions in China and Turkestan early in this century are particularly important when the objects found can be compared with information from such exhaustive studies of the past and present uses of paper in one particular area as Trier's extensive *Ancient Paper of Nepal.*[20] In the light of these combined finds, an unusually clear picture of the role of paper in Asia emerges. Paper offered the common Asian an economically viable way to participate in his religion and to assure his place in whatever afterlife he believed in. Hinduism, Zoroastrianism, Manichaeism, and even Islam — when mingled with Buddhism and Taoism in the oases of the central Asian trade routes — were influenced as well as influential. These religions, as practiced in China, adopted some of the everyday rituals of other faiths even as they engaged in the publishing of their own sacred literature. Conservative Hinduism was slower to adopt paper as a ritual object and as an historic record-keeping surface. Traditionally an oral religion, Hinduism clung more closely to the use of the traditional palm leaf for its few written manuscripts and prayer images, but some Hindu books were eventually published, printed on paper. Even the Turkish Moslems in Chinese Turkestan, prohibited by Islam from printing the Koran, published almanacs — both for Mohammedans and for others — as well as other secular books.[21]

The role that paper played in the Moslem world is less clear. Islam — with its strong emphasis on the written word of Allah, or the traditionally hand-written Koran, and its prohibition of the production of realistic images — responded to paper differently than did the predominantly Buddist Chinese culture. Paper was hailed as an aesthetically pleasing surface for traditional calligraphy and an economical medium of communication which was much more desirable than either papyrus or vellum. The use of paper spread quickly throughout the Arab world, and by 869 Samarkand was famous for its paper: an Arab writing a letter of thanks during this era closed with the words "pardon the papyrus," and a Persian traveler to Cairo mentioned that fruit and vegetables in the marketplace were wrapped in paper![22]

Frustratingly little information exists about the details of this role of paper in the four hundred years before the process of papermaking was again the victor's spoils — this time the Christians' in Moorish Spain. The Swedish paper historian Henk Voorn, enticingly mentions that different colors communicated different meanings, paralleling those in Chinese culture: blue paper was used for mourning and also for the wrapping of medicines; red paper signified joy and happiness and was only permitted for use by the highest officials writing to the court in Cairo, and "in Persia, red paper clothing was worn by those who asked to be received by the sovereign."[23] Excavations such as those at El-Fayyum in Egypt indicate that the more mystical uses of paper — for votive and protective images, divination and purification rites, and for absolution — existed among the Arabs but perhaps were less widespread than among other groups.[24] Of this enormous find of documents — over one hundred thousand sheets and fragments of paper, papyrus, and parchment — only about fifty documents were printed, as opposed to hand-written. Although these fifty examples date from as early as the tenth century until the middle of the fourteenth century, their similarities are remarkable: they are all in Arabic, they are limited to text and geometric ornamentation — thereby conforming to the Moslem prohibition against pictures — and they all appear to have been printed in the Chinese manner, by rubbing the back of the paper with a soft baren. Most importantly, they all deal with the Moslem religion. In addition to texts from the Koran, these documents include special protective charms, one of which combines Koranic quotations with a purported correspondence from Mohammed and a section to be filled out by the owner requesting to be saved from a particular evil.[26]

One can only hope that the results of future research will contribute to a more accurate picture of the role of paper in the period of Moslem domination. Because this period occurred during the time of the vast Mongol Empire and the European Crusades to the Middle East, we can assume that Arab practices influenced the transfer of the use and production of paper from the East to the West, to the awakening civilization in Europe. One is tempted to believe that in the Moslem world, as in China, the actual uses for paper were more numerous than the histories of the time describe, for the early uses of paper in Europe tend to confirm this hypothesis that secular and functional as well as religious uses of paper somehow survived the Arab period.

The process of papermaking was introduced to Europe via Spain in 1150 and via Italy in 1276. The Crusades had stimulated travel and trade, and imported paper had been available for several hundred years from the Arabs in the papermaking centers of Damascus and Bambyx. Until it changed from an expensive import to a local product, however, paper could not fulfill its greatest potential as a means of visual communication that was cheaper than vellum and parchment. Paper's first uses in Europe were primarily religious, as they had been in Asia; it became the medium for those in power, the literate clergy, to grant commoners limited access to the benefits of piety—a feeling of control over their lives. By the end of the fourteenth century, paper had largely displaced parchment as the writing material of all but the wealthy.

In the course of its migration to Europe paper production had changed somewhat. Technical differences such as the use of stiff writing pens rather than the soft calligraphy brushes used by the Asians inspired the development of a harder, smoother, and more opaque paper surface. The laborious rubbing of rice paste into the surface of the paper with a stone was replaced in Europe by the use of gelatin sizing. The development of the stamper for hydrating the rag fibers was another labor-saving improvement that made paper production more economical.

Lack of documentation leaves much to speculation about earlier prints in Europe, but it appears that the oldest surviving woodcut prints had been produced in France and Southern Germany by the end of the fourteenth century. One of the earliest examples is a hand-colored woodcut of St. Christopher printed in Southern Germany in 1423. This image is accompanied by a reassuring script which roughly translates,

In whatsoever day thou seeist the likeness of St. Christopher, in that same day thou wilt from death no evil blow incur.

The similarity between this print and the Buddhist charms of Asia is remarkable. Christian images of the Crucifixion, the life of Christ, and the saints—particularly those, like St. Christopher, whose spheres of influence were of concern to the average illiterate person in his daily life—became immediate commercial and spiritual successes. These images were sold by the church for the establishment of home altars, for pasting into document boxes, for wearing sewn to one's clothing, for affixing to wafers to be eaten by ill persons or fed to ill domestic animals, and even for pinning to shrouds for help in purgatory. The indulgences in Europe, the charms of Asia, and the "passports" of the Aztecs all served the same purpose.

The early block printing of Tun-huan, of Egypt, and of Nuremberg are in their essence the same. The language is different and the religion is different, but they all represent the effort of the common man to get into his hands a bit of the sacred word or a sacred picture, which he believed to have supernatural power, but which he could not himself write or paint and could not afford to buy unless duplicated for him by some less laborious process.[27]

Playing cards, the other form that surviving fourteenth century woodcut prints take, are also mystical in origin. Having evolved from Chinese dice games of divination and chance, paper cards were again developed as a less expensive surrogate for carved ivory dice. The extensive contact between the Mongol Empire and the Crusades in the Middle East and Mongol contact with Eastern Europe served as the points of transfer for card games as well as other games such as chess and polo. The cards caught on immediately throughout Europe in the form of tarot cards for fortune-telling and a number of other card games. Despite the small numbers of examples of these early printed cards, we are aware of their popularity because of a 1441 request by the woodcutters and makers of playing cards in Venice that the importation of playing cards be forbidden, as it was ruining their business. The request was granted by the City Council.[28]

Block books were printed in Europe in the fourteenth century. Like their Asian counterparts 600 years earlier, the illustration and text for a page of one of these books were carved from a single block to which the original image and text had been pasted, face down, as a pattern. European block books followed the Greek tradition—already adopted for European manuscripts—of sewing together groups of folded sheets of vellum paired so that the pages could be matched inner to inner and outer to outer. This arrangement was necessary because the water-base ink in which the books were printed would smear if images were printed on both sides of a single sheet.

It has now been established that movable type was first developed in China and that cast metal type was developed and used extensively in Korea a half century before its use by Gutenberg. It was the fortuitous combination of movable type for a language with an alphabet, oil-base printing ink, and the availability of an inexpensive printing surface—*paper*—that permitted the expansion of learning that characterized the Renaissance, the Age of Reason, and the beginnings of the modern Western world. This period of rapid development would not have been possible were it not for the economics of paper. As in Asia, the first printed books were religious: the *Bible*; *Ars Moriendi*, a manual for a pious death; and *Bible Paupernum*, a visual anthology relating Old Testament prophesies to New Testament events.

With the increased knowledge and broader education that resulted from the Renaissance, the power of the church decreased: it was no longer the central source of knowledge and education. Having come into use at a much later stage of European history than Chinese or Japanese, handmade paper had never assumed a large role in the creation of functional objects; a culture which had glass didn't need paper windows. As the Renaissance advanced, paper's importance in the fine arts continued—particularly in the art of printmaking, which had separated itself from the exclusive production of religious images. The rapid development of new printmaking processes to meet specific commercial needs also created new artistic applications for the printmaking processes. Indulgences sold to nineteenth century pilgrims were fashionable lithographs. The rapid development of new printmaking and new printing processes inspired equally rapid changes in the processes of papermaking and created an incredible demand for paper.

Together these changes resulted in a changed paper product. The role of paper as the powerful bearer of mystical images declined sharply. Indeed over the past five hundred years, paper has exerted power almost exclusively as a representative of officialdom in the forms of agreements, deeds, diplomas, banknotes, and certificates. The watermark became paper's own authentication. Knowledge and the capacity to enforce sanctions have replaced the supernatural as the source of power. Although paper is still the carrier of this authority, it no longer possesses the sense of magic that it had during the eras of its spiritual significance.

Paper As a Contemporary Art Medium

The burgeoning quantitative growth of paper and the rapid development of technology have been mutually catalytical. The mechanization of the papermaking process, the development of wood pulp paper, and the use of paper as a communications medium for writing, teletypes, photocopies, and computer

print-outs have made paper essential in a whole new way in contemporary society. Paper has "progressed" to newsprint and copier paper; it has increased in economic importance but diminished in aesthetic and spiritual presence. However inferior they may be aesthetically, modern papers are a key factor in the economic and intellectual functioning of society. Paper continues to be the means by which power is dispersed to many by a few. The average Mayan may not have understood the complex scientific principles that were described by pictographs in the *tonamatls* or related to the symbolism of the sacrificial ceremonies, but he had his own paper ceremonies and knew that he too would have his "passport" to Mictlan. The average Buddhist didn't understand the sutras and esoteric writings of his faith, but he had his charms and household deities which allowed him to participate in his own search for piety. Similarly the devout Christian in the fourteenth century had his indulgence as his ticket to participation in his own salvation. In the complex maze of today's paper documents the average person does not completely understand the official papers, often in the form of computer print-outs, that he receives from his tax authority, his local government, and his workplace. Interpreters — now lawyers instead of the clergy of the past — are frequently needed to translate these documents. These papers have power; today's citizen knows to "get it in writing." But society has lost the blind confidence that anyone is fully in charge. Modern man is on the verge of losing even the comfortable tangibility of the xerox papers and newsprint. Soon communication may be completely electronic. Paper, particularly handmade paper, is our last link to this tangible record of the past.

In the last 200 years handmade paper has passed from a necessity to a luxury in the West. Printmaking processes, once superseded as communication processes, became media for the luxury of fine prints. In a similar way handmade paper has become a fine art luxury material used by artists for drawings, prints, collages, and book illustrations and by fine press printers for the publication of limited edition volumes. In the post-war rush to the new and "modern," the crafts that produce handmade objects were nearly lost.

The zeal of twentieth century American art to be "relevant" and technologically up-to-date has pushed the incorporation of new philosophies, new materials, and new processes. The longest-standing tradition in contemporary art is the tradition of rapid change. In the period following World War II the influence of artists who had come to the United States during the war and the perceived need for art which seemed more relevant to the complex times prompted the acceptance of abstract expressionism. The notions that art need not be more than a record of its own creation and of the dominance of the subconscious permitted gesture and abstraction to replace pictorial subject matter. In the sixties, technological and economic factors left their mark on the work of many influential artists. Art sought to align itself with the forefront of developing technologies such as photography, computer art, video, and the sophisticated industrial processes that could be used for the making of art. At the same time, pop art left no doubt about is subject matter, but provoked just as many questions as to its meaning as had abstract expressionism. The emphasis on technology and commercial techniques elevated printmaking, particularly silkscreen and lithography, and produced a profusion of perfectly identical editions: this phenomenon, along with the minimal and conceptual art of the sixties and early seventies took this idea of modernization and technology to its limits. From the start, however, there was an opposition. The exuberant combine paintings of Robert Rauschenberg, the coolly intellectual work of Jasper Johns and the sensuous work of Jim Dine offered alternatives. Stylistic pluralism, extreme size, complex new processes, and sophisticated marketing brought the contemporary art world into the twentieth century financial circles with a bang. Paper — as the substrate for prints — once again brought an ever-escalating art market within the range of the average person. "Big name artists," whose works on canvas were too large and too expensive for the average collector, were affordable as prints.

The seventies responded to this commercialization of contemporary art with a return of art to a more private domain. Artists pulled back from technology and from the emphasis on over-rationalization that was fostered by the writings of conceptualists and an increasing number of art critics — the new priests and interpreters of the art world. Rosenberg described his view of the position of contemporary art:

There is no turning back to the organic astuteness of the traditional craftsman, nor will surrendering to his medium liberate the

artist from the obsessions of thought.[29]

The preoccupation with a search for the appropriate visual language for contemporary American art continues. The seventies introduced new concerns: ecological problems of limited energy, pollution, and over-population; the irrationality and human waste of the Vietnam War; and the increasing complexities of modern times continued to make the artists aware that a new language was needed. Bilgé Friedlaender summarizes this awareness:

When the airplane takes off I concentrate on being alive. I check my senses and look at the world over which I become suspended in this man-made miracle. First the ordered patches of fields and waterways hit my eyes, then I am over the clouds, the clouds so white and weightless. We fly over the Delaware River, as it empties itself into the Atlantic Ocean, a spectacular sight, a grand weaving of curving lines. No wonder our art can no longer only relate to still life and human form. Our horizons are so wide, our consciousness of the world so expanded, that we must create a new visual language.[30]

In a country where being new, different and "relevant" has generally carried more weight than has tradition, American artists have looked to other cultures for inspiration but have not felt tied to any one tradition. They have had a unique opportunity to choose among many cultures and traditions. Before the sixties artists could select from among only the traditionally defined media, but in recent years working in several media and changing from one medium to another have become common. Indeed, media categories have become so indistinct that limiting entries for competitions and exhibitions by media is nearly impossible: prints include photography techniques, monotypes are prints but not multiples, paintings are now three-dimensional and sometimes fill up entire rooms, sculptures are more akin to buildings. Virtually everything may now be more safely called "mixed-media". The sole remaining limitations of an artist are his own expectations and definitions of media. Robert Rauschenberg has expressed his desire to eliminate even this last barrier.

I'd like to think that the artist could be just another kind of material in the picture, working in collaboration with all the other materials... I know this isn't possible, really.... But if I can throw enough obstacles in the way of my own personal taste....[31]

The American tradition in crafts has also been affected by this search for a new visual expression. Craftspeople have the same license to cross boundaries. In America the concept of craft has been

not a process per se, but rather a process in the service of an idea. First in the area of ceramics, now with other crafts as well, this has reduced the tradition of technique, geared towards functionality, to just another option for a purely aesthetic statement. At a time when so many of our functional objects are mass-produced, the return of the unique object made with natural materials and perhaps more interest in aesthetics than in utility is another example of the boundary-crossing and expansion which characterizes recent American art.

More and more artists in their work are trying to capture the vanishing human space and materials. More than ever artists are sensitized to the inner language of their materials.[32]

It is in this context that handmade paper has surfaced as a "new art medium" in the United States. The art of hand papermaking survived changing American tastes in art by virtue of a few notable individual efforts: Dard Hunter's exhaustive research and extensive publications, Douglass Howell's dedication to the study of fibers and his unique manipulation of handmade paper for aesthetic effects, and the publication and support of limited edition press books which have existed — somewhat anachronistically — since the thirties.[33] In the late sixties a desire to introduce hand papermaking into university printmaking and fine press programs launched the revival of the process of hand papermaking. The early work of shops such as the Institute for Experimental Printmaking was the beginning of the use of paper as an art medium in modern America. Originating from several areas of the country, through different "family trees," this medium has attracted tremendous interest throughout the United States.

The use of paper as a medium appeals to artists today for several reasons. It allows a swing away from impersonalized art towards the involvement of the hand of the artist in the creation of his/her own work. It is a new, very flexible, and plastic medium that allows considerable cross-media experimentation, yet it has associations with nature, history, fine art, and the varied traditional uses of paper for functional and spiritual objects. Paper has an aura of authority and a democratic simplicity about it. As the humility of paper appealed to esoteric Buddhism, so too do the simple, pure technique, the natural materials, and the meditative nature of the process of papermaking appeal to the intellect of today's artist. Paper offers a large palette of visual and physical characteristics to both artists who

make their own paper and those who use paper made by others. Once paper is freed from its role as a substrate, its tremendous potential becomes evident. Perhaps the most attractive aspect of paper is this absence of precedent for its use as an American art medium, and relative freedom from expectations and personal or cultural prejudices it offers artists.

In the face of this freedom, artists have in the last ten years successfully expanded paper's possibilities well beyond its previous range. The danger with this freedom from tradition is that experimentation and technical misinformation sometimes lead to material which — often unbeknownst to the artists — is not physically and chemically sound. Fortunately, due to responsible work by mills like Twinrocker, the Kensington Paper Mill, Imago, Dieu Donné, and Tyler Graphics and to individuals such as Timothy Barrett and Winifred Lutz and many others, general knowledge and education about process is improving. From this knowledge processes for paper as an art medium — as distinct from paper as a printing and printmaking surface — are evolving.

After a decade of exploration by artists, patterns in the use of paper as a medium have begun to emerge. We can now see that paper allows an artist to move through layers that would otherwise be occupied and obfuscated by the baggage of process, media definition, art historical expectations and the artist's own expectations. Working with an interdisciplinary medium the artist is able to get in touch directly with a very deep self — to communicate ideas that are free from these expectations usually loaded on more defined media. The material itself relates to this type of expression. For many artists the initial interest in the formal flexibility of paper as a medium ultimately affects their approach to the other media in which they work.

Individual Approaches to Paper

The artists represented in *New American Paperworks* have clearly discovered paper to be part of a solution to this need for a new visual language. Their reasons for working with paper are as diverse as the directions from which they have come to their use of paper. For each of these artists, paper offers a means to get to that voice which speaks for the intuitive self.

Sam Francis and Ken Noland are colorists. Although Noland works with colored pulps and Francis works with pigments and white pulp, both artists have found that the flexibility of working with paper

significantly expands upon the range of effects possible in their similar work with paint. Francis describes making monotypes in handmade paper at the Institute of Experimental Printmaking:

What has happened is that I have found a way to get into that machine....When I am working with these prints, I *am* the paper, I *am* the paint, I *am* the machine...I am not trying to "make something"....The only image I get when I talk about those...is that I see brilliant yellow, suddenly...and Jacob's ladder...and the ritual opening and closing of a door.[35]

For Noland papermaking is akin to a drawing for a painting, with the associated freedoms and informality. He considers it a craft which is being elevated to a fine art, and it is the very craft of it — the ritualistic repetition and its relationship to other crafts such as weaving — which appeals to him and complements his work as a painter.[36]

For Helen Frederick, Nancy Genn, and Don Farnsworth, paper also meets a need to work between two media in which the artist has extensive experience. Frederick is working from a substantial background in printmaking and experience with textiles towards a more painterly means of expression. She speaks of paper's "forgiveness, its extension of boundaries, and its ability to take many forms." Genn was working between painting and sculpture at the time she began working with paper; she had been making paintings on very large sheets of paper and mounting them on stretched canvas. In her works for this exhibition she has come full circle — to large panels painted *in* paper *with* paper and then mounted on canvas backings. During a fellowship in Japan, her interest in texture led to a series of prints in which the image combines the watermark of a translucent sheet of paper with the lithographic printing on either side of the sheet. For Farnsworth working with paper pulp laminations and paintings in pulp is a way to bring together his experience as a sheetformer, a collaborator with other artists, and his extensive background as a printmaker and professional printer. The work he is doing in abaca pulp combines his extensive experience to produce a series of unique and exceptional works of art — on the same high level as his fine collaboration.

Because of its ability to take any form and still be lightweight — even translucent — paper is an ideal medium for working in the area between sculpture and painting or printmaking. For Suzanne Anker, Charles Hilger, and Winifred Lutz this three-dimensionality is paramount. The possibilities for casting paper are technically the most significant

innovations in the use of paper as a medium which the new fine art paper technology has achieved in the United States. Anker's early works, cast forms made in latex moulds fashioned from ordinary cardboard, played upon the tension between what is real and what appears to be real. Anker worked with the moulds, developing a technique which allowed her to repeatedly expand the limitations of size. Although she ultimately decided that size for its own sake was no longer necessary, her extremely large castings permitted a dialogue with her period of working with stone sculpture. Her more recent works employ a primarily two-dimensional, painterly approach to achieving three-dimensionality. Paper has made Anker's successive transitions possible and has always served her playfulness with illusion. Hilger began working with cast papers and quickly moved on to vacuum-formed works which permitted the use of traditional characteristics such as the mould-made surface of a sheet and the luxuriant deckle edge which characterizes his white papers. But paper has also facilitated his new ventures into a more restrained dimensionality—almost like a large-scaled intaglio embossment of the paper surface—such as one sees in *Black Bamboo*. For Lutz working with paper presented several challenges. Her extensive knowledge of casting techniques led her to devise a unique lamination-casting process using a variety of specially designed moulds.[37] She has also done extensive research on indigenous bast fibers which can be combined with shorter-fibered pulps so that the final sculpture takes advantage of the optimum characteristics of each fiber. The translucency of the bast fiber papers and the effect of changing natural light has been important in the development of her recent *Dayfinder* series.

For Robert Rauschenberg and Charles Christopher Hill, the initial attraction of paper was as a found material for use in multimedia "paintings." Rauschenberg's collages, early monotypes, and combine paintings of the early fifties foreshadowed his first venture in hand papermaking twenty years later at the Richard de Bas Mill. Rauschenberg's entire body of work, occurring as it does between the standard definitions of media, has pioneered the interdisciplinary approach which reigns today. His intuitive understanding of material and symbolism have produced works in France and India which are each particularly apt for those cultures. Hill's use of paper is also iconoclastic. For Hill the very impermanence of the commercial papers he uses are a large part of their

appeal to him. The series represented in this exhibition presents a fascinating interplay among several techniques. The first lithograph on black Arches paper sets the tone for the series. Hill then collaborated with Twinrocker to produce handmade papers with embedded laminations which replicate the curvilinear grid system in the lithograph. Later, at Cirrus Editions, Hill printed a lithograph on top of the handmade paper from Twinrocker: the resulting image is both *in* the paper and *on* the paper. The series finishes with a stitched and composted "painting" done with the proofs from the lithographs. Handmade paper has added a new dimension and elegance to his already complex work.

Joseph Zirker and Bob Nugent are both artists who make their own paper and use it for images of an extremely personal nature. Zirker's early work in paper was a direct result of his extensive use of viscosity printing principles for the printing of monotypes. His first handmade paper pieces were assemblages, or layers of pulp with memorabilia laminated within and monotypes printed on top. After several years of working with handmade paper, Zirker's new paper reliefs are dramatically different and seem to come from an intensely personal part of himself. Nugent's paperwork began with paper serving its traditional role as the bearer of information, love letters, correspondences, ships' logs, and nautical record-keeping. His latest works involve the construction of large shelter-like sculptures in the woods, where they are left to weather and interact with the elements for several seasons and then embellished with branches, fibers, and other elements found at the site, gradually becoming works like *Morgan Meadow Markers*. The material itself and its own qualities are taking a stronger role in Nugent's work.

Steven Sorman, Cynthia Starkweather-Nelson, and Caroline Greenwald all utilize handmade papers from the Orient in their work, but the end results are quite different. All three are attracted to the high quality and delicate strength of the papers. Sorman uses a wide range of papers—some brightly colored, some muted and natural. He uses these papers like a palette and is one of few artists who can create images using incredibly strong-colored papers in a way that permits the papers and the image to be delicately balanced so that there is a dynamic inter-change between the two. Starkweather-Nelson uses the thin papers primarily for their layering facilities and effects. Upon the many layers of paper she continues to build layers of pigment so that in her *Journal* series, for example, one really

has the sense of layers of writing but also of layers of involvement and expectation from the inner self. Greenwald's evocative and lyrical works are among the most puristic uses of paper. She emphasizes the fold lines in natural colored Japanese papers with fibers and occasional rag or abaca pulp to create her wispy and ethereal images. Despite their appearance, these cloud and wind and water maps are as strong as the elements they evoke. The heroic launching of *Feather Book* on a windy, 6°F. day conjures up imagined memories of the sixty-foot huun banners used in those ancient Aztec ceremonies. The incredible strength belies the sheer luminosity of these totally unique works.

Neda Al-Hilali and Sirpa Yarmolinsky both come to the use of paper from back-grounds as innovative fiber artists. Al-Hilali found that the connotations and associa-tions which the use of fibers brought to the pieces limited her ability to completely transform and dominate the material. In her work with paper she is an alchemist. From rolls of paper she produces wonderful plaited forms which become large mysterious creatures when dragged across the beach by a series of sprightly figures reminiscent of a Fellini film. Similarly plaited works become intri-cately patterned surfaces with large dragon-like "scales" under which one can see the dyed papers, unpainted, recollect-ing their former existence. Large lami-nated furls of painted papers create lyrical environments the elements of which interact and play with one another as in *Cassiopeia Suite*. The rigidity of the Finnish tar papers Yarmolinsky uses give her work a strength and presence not seen in her fiber pieces. The pieces are black, but not connoting darkness or evil; instead they have a blackness that is more suggestive of nighttime and a mystical, spiritual energy. Yarmolinsky has transformed a utilitarian material into an exciting sculptural piece. Indeed the trend in her recent work is towards an increasingly sculptural quality, but one senses that the painterly use of color will remain important. It is the combination of structure and painterly illusion which creates the powerful mood of the work.

Bilgé Friedlaender, Ke Francis, and Michelle Stuart are involved in their own visual languages in which using a variety of papers is a key element. Friedlaender uses a wide range of papers from the East and West, particularly for the making of artist's books of exceptionally fine quality that combine papers from dramatically different origins in ways that demonstrate a tremendous sensitivity to the character of the papers themselves. Friedlaender often keeps papers for years, waiting until a work evolves for which the paper is

suited. Her intuitive sense of paper and other natural materials is complemented by her notably rational conceptualization of her work. *Notes on River/House/Book* is an example of the many levels of meaning and intellectual complexity on which her formal work is based. It also demonstrates the range of potential visual arrangements that the *River/House/Book* can assume. Ke Francis is deeply involved in the literal and figurative ceremonies and accommodations which the people of the southeastern United States have built up around such awesome natural phenomena as hurricanes and tornados. Using these local tales and remedies as points of departure, Francis has developed his own mythology and delineated a ceremonial area where the spirits reside in the woods near his isolated Mississippi home. Stuart's work is at once highly intellectualized and extremely ritualistic. In her evocations of peoples and spirits of past civilizations she has succeeded in what Rosenberg had thought was impossible: the blending of the ancient with the new, the primitive with the very sophisticated, accurate geological information with mythological legends.

New American Paperworks set out to survey Eastern and Western papermaking and paper using traditions and to examine the reflections of these traditions in the work of twenty contemporary American artists who have chosen paper as a medium. What we have discovered is that whether they make it themselves or respond to paper made by others, these artists' work is shaped in large part by the nature and essence of the paper itself. Such small aesthetic decisions as the selection of a paper or fiber or process to work with seem to engender involvements with paper that are not unlike the mystical attraction that it has exerted since its beginnings in the pre-paper world of Polynesia, through the advent of true paper in ancient China, and the blending of spiritual and functional uses of paper in Japan. Because these artists' involvement with paper so eerily evokes the revered traditions of Oriental handmade papers, it is with great pleasure that we prepare *New American Paperworks* for exhibition in the Far East after its showings in the United States.

Notes

1. Tsuen-Hsuin Tsien, *Written on Bamboo and Silk: The Beginnings of Chinese Books and Inscriptions* (Chicago: University of Chicago Press, 1962), p. 138.
2. For further discussions of the chemistry of paper please refer to the following books:
James Clark, *Pulp Technology and Treatment of Paper* (San Francisco: Miller Freeman Publications, Inc., 1978).
Roy P. Whitney, "Chemistry of Paper," in *Paper—Art and Technology*, ed. Paulette Long (San Francisco: World Print Council, 1979), pp. 36–44.
3. For further information on the two major papermaking techniques, *tamezuki* and *nagashizuki*, please see "Standard Hand Papermaking Techniques," by Timothy Barrett, in this catalogue.
4. Carla Freitas, "Tapa in Ancient Hawaii," in *Tapa, Washi, and Western Handmade Paper: Papers prepared for a symposium held at the Honolulu Academy of Arts, June 4–11, 1980* (Honolulu: Honolulu Academy of Arts, 1980), p. 14. Additional material is from an interview with Ji-xing Pan, Associate Professor of Research, Institute of History of Natural Science, Peking, February 28, 1982, Washington, D.C.
5. Freitas, "Tapa in Ancient Hawaii," p. 15.
6. Victor Wolfgang Von Hagen, *The Aztec and Maya Papermakers* (New York: Hacker Art Books, 1977), pp. 77–78.
7. Hans Lenz, *Mexican Indian Paper, Its History and Survival* (Mexico City, Mexico: Rafael Loera Y Chavez, Editorial Libros de Mexico, 1961), pp. 19–48, 113–149.
8. Ibid., p. 130.
9. Ibid., p. 123.
10. Thomas Francis Carter, *The Invention of Printing in China and Its Spread Westward*, second edition (New York: The Ronald Press Company, 1955), p. 9.
11. Tsien, *Written on Bamboo and Silk*, pp. 132–138. The discussion of the word *chih*, held by some to indicate the existence of a quasi-paper containing silk refers to a lexicon, *Ku-chin tzu-ku*, compiled by Chang Chich in 232 A.D. Chang discusses the change in the radical from a silk radical in the character which now means paper to a cloth radical after the invention of paper. Tsien concludes, "Although the sounds of the two words remain the same, their radicals are different. Hence it cannot be said that ancient paper is the same as modern paper." References to Mr. Pan's research are from an interview in Washington, D.C., on February 28, 1982, and a lecture, "On the Origin of Papermaking in the Light of Newest Archaeological Discoveries," given at the Smithsonian Institution, March 2, 1982. This material has been

published in his book *Zhongiguo zaozhi jishu shi gao* [History of Papermaking Techniques in China] (Beijing: Wen Wu [Cultural Relics] Press, 1979), chapters I and II. (This book will be published in English in 1983.)
12. Edwin O. Reischauer, and John K. Fairbank, *East Asia: The Great Tradition* (Boston: Houghton Mifflin Company, 1958), pp. 36–41.
13. Clarence Burton Day, "Paper Gods for Sale," *China Journal* [Shanghai] 7, No. 6 (Dec, 1927), pp. 277–284.
14. Dard Hunter, *Chinese Ceremonial Paper: A monograph relating to the fabrication of paper and tin foil and the use of paper in Chinese rites and religious ceremonies* (Chillicothe, Ohio: The Mountain House Press, 1937).
15. Ibid, p. 75.
16. Bunsho Jugaku, *Paper-making by Hand in Japan* (Tokyo: Meiji-shobo, Publishers, Limited, 1959), pp. 10–11.
17. Sukey Hughes, *Washi, the World of Japanese Paper* (Tokyo, New York, and San Francisco: Kodansha International, 1978), pp. 54–55. Professor Seishi Machida, paper historian, Kyoto, has pointed out that generally the priests do not actually burn the kamiko robes at the end of Omizutori. The robes which have not been ruined are saved to be used as spares for the next year's ceremony. Although each monk does make a new one each year, sometimes the new ones are torn and the spares are used.
18. Jesper Trier, *Ancient Paper of Nepal* (Copenhagen: Jutland Archaeological Society Publications, 1972), p. 17. Trier cites another source as the originator of this theory: Sasuke Kakao, "Transmittance of Cultivated Plants Through the Sino-Himalayan Route," in *Kihara*, 1957, pp. 397–442.
19. Carter, *The Invention of Printing in China*, p. 8.
20. Trier, *Ancient Paper of Nepal*.
21. Carter, *The Invention of Printing in China*, pp. 94–95.
22. Ibid, p. 136.
23. Henk Voorn, "Papermaking in the Moslem World," *Papermaker*, 28, No. 1 (Feb. 6, 1959) p. 38.
24. Carter, *The Invention of Printing in China*, pp. 176–77.
25. Ibid, p. 181. See note 2. The earliest dates of this finding are disputed and Carter cites other sources.
26. Ibid, p. 178.
27. Ibid, p. 179.
28. Arther M. Hind, *An Introduction to a History of Woodcut* (1935; reprinted. New York: Dover Publications, Inc., 1963), pp. 82–83.
29. Harold Rosenberg, "Art and Words,"

in *Idea Art*, ed. Gregory Battcock,
pp. 150–164. (New York: E.P. Dutton,
1973), p. 163.

30. Bilgé Friedlaender, unpublished
journals, October 7, 1978.

31. Calvin Tompkins, *The Bride and the
Bachelors* (London: Weidenfeld and
Nicolson, 1962).

32. Friedlaender, unpublished journals,
October 7, 1978.

33. For further documentation for the use
of handmade paper in fine art printing,
please see the following:
Andrew Robison, *Paper in Prints*
(Washington, D.C.: National Gallery of
Art, 1977).
Janet Flint, *New Ways with Paper*
(Washington, D.C.: Smithsonian
Institution Press, 1977).
Jane M. Farmer, *Paper As Medium* (Wash-
ington, D.C.: Smithsonian Institution
Traveling Exhibition Service, 1978).
Jane M. Farmer, "Why Paper, Why Now?"
Visual Dialog 3, No. 4. (Summer, 1978),
pp. 2–3.

34. Dates and history are, of course,
subject to much tiresome controversy as
to who was the first with any given idea.
For this reason, we shall consider the
beginning of paper as medium the time
that it began to get considerable public
attention, that is the last ten years.

35. Jan Butterfield, *Sam Francis*,
exhibition catalogue (Los Angeles: Los
Angeles County Museum of Art, 1980), pp.
17 and 14.

36. Interview with the artist, South Salem,
New York, September 3, 1981.

37. For an excellent description of Lutz's
casting technique, please see her article,
"Casting to Acknowledge the Nature of
Paper" in *International Conference of
Hand Papermakers*, documentation of
conference held in Boston,
Massachusetts, October 2–5, 1980
(Brookline, Massachusetts: Carriage
House Press, 1981).

Lenders to the Exhibition

Fendrick Gallery, Washington, D.C.
Getler/Pall Gallery, New York City
Jean Milant, Cirrus Gallery, Los Angeles,
California
Steven Nelson, Minneapolis, Minnesota
Peter M. David Gallery, Minneapolis,
Minnesota
Smith Andersen Gallery, Palo Alto,
California
3EP Ltd., Palo Alto, California

Exhibition checklist

Works are loaned courtesy of the artists,
unless otherwise indicated.

All measurements are in centimeters and
are subject to some variation due to the
irregular edges of most works. Height
precedes width, and depth is noted when
relevant.

The geographic designation indicates the
most recent studio location of the artist.

Checklist

Neda Al-Hilali, Santa Monica, California

1. *Cassiopeia Suite*, 1982
 a. *Cassiopeia's Court Entertainment*
 Dyed, laminated and painted paper.
 223.5 x 317.5
 b. *Cassiopeia's Towel*
 Dyed, laminated and painted paper.
 203.2 x 261.2
2. *Pearly Gates*, 1981
Plaited, dyed paper, pressed and painted.
198.1 x 185.4

Al-Hilali's background combines
experiences of her native Czecho-
slovakia; art training in Europe and
the Middle East, and graduate school
and teaching in Southern California.
An initial involvement in innovative
uses of fiber techniques and materials led
to her present work, which uses these
fiber techniques to transform commercial
papers. Rolls of paper are dyed, plaited,
flattened, and painted to produce rich
decorative surfaces. The intricate patterns
created in unrolling the dyed rolls to dry
led to the newer works in which papers
are laminated rather than plaited in order
to preserve these spiraled patterns as the
basis for further surface decoration.

Suzanne Anker, New York City, New York

3. *Wing Run*, 1980
Cast handmade paper with charcoal and
carborundum. Unframed squares, each
91.4 x 91.4 x 15.2

4. *Corona Series*, 1981
Handmade pigmented paper, made at
Dieu Donné, New York City.
74.9 x 100.3

5. *Corona Series*, 1981
Handmade pigmented paper, made at
Dieu Donné, New York City.
74.9 x 100.3

6. *Corona Series*, 1981
Handmade pigmented paper, made at
Dieu Donné, New York City.
74.9 x 100.3

From a background as a printmaker,
Anker initially worked with cast paper,
made in latex molds. A fascination with
trompe l'oeil led to the use of cast paper
as a reproduction of torn, corrugated
cardboard collages. The cast paper
prompted an interest in using sculptural
reliefs in paper, marble, and limestone—
to experiment with combinations of
paper and stone, actual and drawn
shadow, and size versus scale. The newest
works take the tromp l'oeil interest in a
more painterly direction, using colored

pulps to explore the line between actual
and apparent three-dimensionality.

Don Farnsworth, Oakland, California

7. *Nagashizuki Series*, 1981
Handmade paper (abaca and kozo pulp)
and inclusions of same.
76.2 x 54.6

8. *Nagashizuki Series*, 1981
Handmade paper (abaca and kozo pulp)
and inclusions of same.
76.8 x 56.5

9. *Nagashizuki Series*, 1981
Handmade paper (abaca and kozo pulp)
and inclusions of same.
76.5 x 55.2

Trained as a chemist, paper conservator,
and professional fine art printer,
Farnsworth—the only artist represented
in *New American Paperworks* who is also
a production hand papermaker—brings a
tremendous technical knowledge and
understanding to his own work. With his
partner, David Kimball, Farnsworth
produces fine custom papers and special
printmaking sheets and collaborates with
artists in his shop to produce paperworks.
Farnsworth's own work is rooted in
printmaking. For several years he has
been making papers in both oriental and

western methods of hand papermaking. His newest work uses these techniques to create a new means of visual expression — in some ways as free as lithography or ink wash, yet with its own unique visual characteristics. The work is a more painterly reaction to Farnsworth's work with bast fibers over the past several years.

Ke Francis, Tupelo, Mississippi

10. *Tornado House Series*, 1981
 a. *Tornado House*
 Wood, tar paper, black handmade paper, handmade straw paper.
 40.6 x 61 x 150
 b. *Tornado Shelters*
 Black and white photograph series.
 11.1 x 37.5
11. *Passage Series Collage*, 1981
 Collage.
 90.1 x 72.4
12. *Passage Disaster Series: "Tornado Strikes House, House Burns, Muse Survives,"* 1981
 Black and white photograph series.
 left: 17.8 x 21.6; middle: 24.8 x 45.4; right: 19 x 15.9

Francis is a sculptor, printmaker and self-described "paper user." His uses of paper include traditional drawings, prints, and collages as well as three-dimensional wall pieces and sculptures. He works with a variety of materials including paper, steel, wood, aluminum, rubber, clay, plexiglas, paint, chalk, and bronze. He is fascinated with paper's contradictory combinations of fragility and strength, flexibility and structure, availability and spirituality. Francis' work with paper is strongly tied to a particular area of land near his isolated home, to the terrible yet beautiful violence of nature reflected in his *Tornado House Series*, and to the spirituality and sacrificial nature of paper as a ritual object.

Sam Francis, Santa Monica, California

13. *Untitled*, 1981
 Color monotype on Arches roll paper.
 108 x 141.6
 Loaned by 3EP Ltd. and Smith Andersen Gallery, Palo Alto, California.
14. *Untitled*, 1982
 Color monotype on custom handmade paper from the Kensington Mill, Kensington, California, pulled at 3EP Ltd., Palo Alto, California.
 81.3 x 106.7
 Loaned by 3EP Ltd. and Smith Andersen Gallery, Palo Alto, California.
15. *Untitled*, 1981
 Color monotype created in handmade paper at the Institute of Experimental

Printmaking, San Francisco, California.
57.8 x 57.8
Loaned by the Institute of Experimental Printmaking, San Francisco, California.

Francis was introduced to the use of paper as a medium by Ann and Garner Tullis at the Institute of Experimental Printmaking in San Francisco. Paper has proven to be a particularly apt medium for Francis' brilliant, translucent colors and his long-time fascination with the empty spaces in an image. The printing of a unique monotype simultaneous with the pressing of a sheet of handmade rag paper allows the colors to be *in* the paper rather than on it; for Francis the fact that the whole work comes together simultaneously in the press makes involvement with paper a more intuitive and personal expression than painting, and continues to be a significant element in his work.

Helen Frederick, Baltimore, Maryland

16. *Survival*, 1981
 Handmade paper diptych: gampi, linen, graphite with embedded copper strips.
 45.7 x 72.4
17. *Survival Entrance*, 1981
 Handmade paper triptych: gampi, linen, cotton and graphite with embedded copper strips.
 50.2 x 128.2 x 3.2
18. *Heian Shrine*, 1981
 Handmade paper triptych: gampi, cotton, silk and graphite with embedded copper strips.
 50.8 x 143.5

Frederick's already broad background in printmaking, painting, and design was expanded further by her introduction to handmade papermaking at Ahmedabad, India. Papermaking offers Frederick a combination of graphic strokes and painterly effects — ultimately determined by the choice of fibers. Paper also affords her a directness, a sense of space, and an expansion of the physical and psychological boundaries that order her work. The resulting work explores areas between the broad color possibilities of painting and the linear qualities of drawing and printmaking. Similarly, it explores areas between the comfort of patterned symmetry and the difficulty of intense personal feelings.

Bilgé Friedlaender,
Philadelphia, Pennsylvania

19. *River/House/Book*, 1981
 Installation piece, consisting of a hut made of bamboo sticks and handmade kumoi paper (55.9 high x 43.2 x 43.2); 9 wood boxes each measuring 3.8 high by 21.6 wide x 86.4 long; and each filled with

sand. Across the top of each box is one of nine river books made with bamboo sticks and handmade paper, uivo for the accordian portion and fukuju for the end portions, each measuring 3.8 x 23.5 x 43.2 folded. Next to each box is one of the nine river stones. Each exhibition space will determine the selection of installation plans. Technical assistance by Kevin Finklea.

20. *Notes on River/House/Book*, 1981
 a. *Notes on River/House/Book*
 b. Photo documentation of *Notes on River/House/Book*
 Color photographs.
 2 photographs, left: 27.91 x 27.91; right: 27.91 x 35.56
Gampi paper by Mr. Naruko, Japan; sago palm leaf and bush rope from New Guinea; gouache, ink and watercolor.
20.3 x 30.5 x 12.7

Friedlaender works in all media — painting, sculpture, drawing, and unique handmade books. Her work ranges in size from miniature to expansive, yet maintains a grand scale. She unites simple natural materials — paper, string, beeswax, and sticks — to create objects and images suggesting mystical origins and relationships. Friedlaender utilizes handmade papers of the East and West, in works that combine the geometric sophistication of her Islamic upbringing, her intuitive sensuality, and her intellectual balancing of the two. *River/House/Book* offers myriad installation possibilities and the accompanying book of notes visually delineates these and the origins of the piece in Friedlaender's own style — at once personal and universal.

Nancy Genn, Berkeley, California

21. *Triptych*, 1981
 Handmade paper.
 left: 151.1 x 108; middle: 150.5 x 94.6; right: 151.1 x 108
22. *Sea Drift #6*, 1981
 Handmade paper, cotton and gampi.
 left: 105.1 x 71.8; right: 105.1 x 71.8
23. *Sedona #10*, 1981
 Handmade paper.
 105.4 x 137.2

Originally a painter and sculptor, Genn first experimented with the use of paper in large mural-sized paintings on oversized rag paper in the early sixties. In 1975 she attended a paper workshop with Garner Tullis and began her present work using paper as a medium. She now has her own papermaking studio in Berkeley. Genn has developed a unique technique for building up layers of pulp and then, prior to pressing, tearing down to reveal different layers below. The texture of the

paper itself, combined with other fibers, gives her work an added material and emotional dimension. Genn was an artist fellow in Japan in 1980, under the fellowship program of the National Endowment for the Arts.

Caroline Greenwald, Madison, Wisconsin

24. *Feather Book*, 1981
Tengujo and "dark silk" Japanese gampi handmade paper, abaca pulp and kite line.
Closed: 61 (106.7 including extensions) x 48.3 x 8.9
Open: 61 (106.7 including extensions) x 1,037.4

25. *Kite Trails*, 1981
Tengujo, abaca pulp and line (the work folds into a case of Japanese bark paper).
Closed: 87.6 x 24.1
Open: 64.8 x 134

26. *Crystal Winds Descending — Map Series*, 1981
Tengujo, gampi Japanese handmade paper, silk line, and abaca pulp (the work folds into a Mexican amatl case).
Closed: 38.1 (without extensions) x 17.2 x 2.5
Open: 101 x 143.8
Courtesy of Fendrick Gallery, Washington, D.C.

As a graphic designer and printmaker, Greenwald had always been interested in the concept of "white on white" imagery. Her work has evolved logically from white images silkscreened onto translucent sheets of Japanese handmade paper, to printed images sandwiched between two sheets of Japanese paper, to the present lyrical and evocative work in which the folds of the papers themselves and added natural fibers have become the drawn lines. Greenwald's work is rooted in her love of the land, skies, and weather of her native Wisconsin, yet it is a universal statement about the delicate magic and power of nature.

Charles Hilger, Santa Cruz, California

27. *Black Bamboo*, 1981
Vacuum formed paper with graphite and charcoal.
213.4 x 213.4 x 2.5

28. *Untitled*
(Only in those locations where Hilger goes to install, presently planned to be Houston, Birmingham, Kyoto, Manila)
Installation piece of white handmade paper. Corner installation, varied size depending on location.

Hilger's beginnings with handmade rag paper were totally Western, totally

sculptural, and extremely dramatic. His use of paper originated in the Western book, Western packaging, and the tactile qualities of paper in contrast to its role as the primary disposable of contemporary society. More recently the emphasis of Hilger's work has become more reflective — figuratively and literally. His work now concerns itself with the contrast between the lacy purity of his extravagant white deckle edges and the exhilarating flash of his new black pieces. Hilger's work is formed on a vacuum table which he and Harold Paris developed with the assistance of engineer Phillip Kirkeby. The table allows the sculptural formation of paper, eliminating the need for a flatbed press to precipitate the required hydrogen bonding.

Charles Christopher Hill, Venice, California

29. *Solomonic*, 1980
Lithograph edition on black Arches paper
79.4 x 61
Edition of 75.

30. *Pyramis and Thisbe*, 1980
Handmade cotton paper with laminations, made at Twinrocker Mill, Brookston, Indiana.
left: 81 x 58.7; right: 79.1 x 59.1
Edition of 9.

31. *Ecstatic*, 1980
Lithograph on Twinrocker handmade paper with laminations.
79.4 x 59.1
Edition of 30.

32. *Nipernicus*, 1980
Stitched paper, lithographs, newsprint.
121 x 92.4
Loaned by Jean Milant, Cirrus Gallery, Los Angeles, California.

Charles Christopher Hill's initial attraction to paper was that it was a readily available, inexpensive material. He has used paper primarily for works in which he stitches many types of paper and some fabric to a back and then allows these pieces to degenerate — often buried under a compost pile — until they resemble a worn paper quilt. Recently Hill has applied some of the concepts from these paperworks to a series of prints, handmade paperworks, and combinations of both. The making of this series involved a collaboration with the prestigious Twinrocker Paper Mill in Brookston, Indiana. Embedded fragments, laminations, printed images, and sewn fragments develop fascinating visual dialogues in, on, and about paper.

Winifred Lutz, New Haven, Connecticut

33. *Dayfinder #3*, 1981
Handmade paper (gampi, milkweed bast,

mitsumata) and wood (poplar, pine).
66.4 x 30.8 x 35.9

34. *Reserve*, 1981
Cooked and handbeaten abaca, dyed with Inko dyes and backed with sisal, on redwood frame.
91.4 x 22.9 x 11.4
(corner piece)

35. *Wedgewood with Indigo*, 1981
Handmade paper (gampi, milkweed bast) and wood (fir).
30.5 x 40.6 x 16.2

Lutz began making paper from indigenous fibers and materials in her youth. As a printmaking major studying papermaking with Lawrence Barker at Cranbrook Academy in Michigan, she focused her papermaking on the making of paper on which to print fine prints. Later handmade paper became the stimulus for Lutz's large sculptures. She has now returned to her original interest in the exploration of indigenous fibers, oriental bast fibers, and linen. Her new work, cast in her unique moulds, combines layered fibers to achieve the desired qualities in her intricate paperworks.

Kenneth Noland, South Salem, New York

36. *Circle I Series (I-40)*, 1978
Handmade paper (cotton rag and gampi) with lithograph, produced and published by Tyler Graphics Ltd., Bedford Village, New York.
50.2 x 40.3

37. *Circle II Series (II-24)*, 1978
Handmade paper (cotton rag and gampi), produced and published by Tyler Graphics Ltd., Bedford Village, New York.
54.6 x 82.2

38. *Horizontal Stripes Series (III-14)*, 1978
Handmade cotton rag paper, produced and published by Tyler Graphics Ltd., Bedford Village, New York.
126 x 82.6

39. *Diagonal Stripes*, 1978
Handmade cotton rag paper.
78.7 x 60.3

It was natural for Noland — a painter who had been blending and staining color into unsized canvas — to respond to the direct methods of working an image in colored paper pulps to which he was introduced by Garner Tullis. Later work with Ken Tyler and at his own paper studio resulted in finer, more subtle combinations of Western rag pulp, oriental papers and pulps, and delicately colored pulps of both types. The making of images in handmade paper pulp is a natural extension of Noland's intuitive sense of subtle color and painterly imagery as well as his gentle sense of play and the interaction of materials and ideas.

Bob Nugent, Sonoma, California

40. *Morgan Meadow Markers*, 1981
 a. *Morgan Meadow Markers, I-V*
 Mixed media, handmade paper and
 wood.
 88.9 x 147.3 x 24.1
 b. Photo documentation of *Morgan
 Meadow Markers*
 Color photographs.
 4 photographs, each 20.3 x 30.5

41. *Siskiou Day Book, Kaiser Meadow*,
1981
Mixed media, handmade paper.
29.2 x 45.7 x 24.1

42. *Sweetbriar Standard Sectional*, 1981
Mixed media, handmade paper and wood.
65.1 x 78.7 x 8.9

Nugent learned to make tapa cloth in
Samoa and studied Western papermaking
in England and Italy. His work with
handmade papers has been consistently
illusionistic, dealing with invented/
remembered Oglala Indian excavations,
correspondences, mariners' pouches
from particular shipwreck sites off North
Carolina, and journals of particular places
and projects. The more recent work is
becoming still more intuitive. The pieces
are documentations made of components
from site constructions of found branches
which are allowed to weather and evolve
out of doors for several seasons prior to
their use in his work. Ultimately Nugent's
work seems to be moving in a sculptural
direction, and handmade paper and its
emphasis on personal documentation
continues to be an important aspect of
the work.

Robert Rauschenberg, Captiva, Florida

43. *Page 2* (from *Pages and Fuses*), 1974
Handmade paper.
55.9 diameter
Collaborators: The Moulin à Papier
Richard de Bas, Ambert, France, and
Kenneth Tyler.
Edition of 11.

44. *Link* (from *Pages and Fuses*), 1974
Handmade paper (rag), pigment, screen-
printed tissue laminated to paper pulp.
63.5 x 50.8
Collaborators: The Moulin à Papier
Richard de Bas, Ambert, France, and
Kenneth Tyler.
Screen printing: Jeff Wasserman, Gary
Reams, Richard Ewen, Marie Porter.
Edition of 29.

45. *Little Joe* (from *Bones and Unions*),
1975
Handmade paper, bamboo, fabric.
61 x 72.4 x 8.9
Collaborators: Charly Ritt, Hisashika
Takahashi, Robert Petersen, Christopher

Rauschenberg, Rosamund Felson.
Edition of 34.
Loaned by the Fendrick Gallery,
Washington, D.C.

46. *Pit Boss* (from *Bones and Unions*),
1975
Handmade paper, bamboo, fabric.
85.7 x 66 x 10.2
Collaborators: Charly Ritt, Hisashika
Takahashi, Robert Petersen. Christopher
Rauschenberg, Rosamund Felsen.
Edition of 28.

Rauschenberg's involvement with paper
is long, varied, and innovative. He has
always worked in printmaking, and his
paintings and assemblages use paper,
often found paper. His long-term interest
in the trompe l'oeil possibilities of paper
are evidenced in his *Cardboard* series
of assemblages done in 1971. In 1973
Rauschenberg made his first handmade
paper series, *Pages and Fuses*, handmade
paper multiples made at Moulin à Papier
Richard de Bas in Ambert, France. Just as
Rauschenberg's combine paintings
helped break down media definitions, the
national acclaim which this series attracted
was important in establishing paper as a
unique medium. In 1975 Rauschenberg
traveled to Ahmedabad, India, to work at
Gandi Ashram on constructions and a
series of multiples, *Bones and Unions*. In
1982 Rauschenberg plans to travel to
China for another collaborative project.

Steven Sorman, Minneapolis, Minnesota

47. *Going for a Reason*, 1981
Mixed media: monotype and bronze leaf
on Nepalese paper.
144.8 x 80
Courtesy Getler/Pall Gallery, New York
City, New York.

48. *When He Could Not Remember
Exactly, He Made Something Up*, 1981
Mixed media: collage bronze leaf on
Shibugami and other Japanese dyed
papers.
100.3 x 111.8
Courtesy Getler/Pall Gallery, New York
City, New York.

49. *Parrot*, 1981
Mixed media: Shibugami and Japanese
dyed papers and tomato can labels.
100.3 x 112.1
Courtesy Getler/Pall Gallery, New York
City, New York.

Sorman is a painter who builds work like
a sculptor and whose primary material is
paper. The colors, texture, and qualities of
different papers — particularly nagashizuki
papers — have been a key aspect of his
work for many years. Be it prints, paper-
work, or paintings, the work boldly
combines papers with other media to
form works that defy standard media

definitions. Sorman eschews over-
emphasis on media, process, or tech-
nique; yet it is his sensitivity to these
issues which marks his work. His
pragmatic, no-nonsense approach to his
art allows it to maintain a close balance
between decorative elegance and honest
simplicity.

Cynthia Starkweather-Nelson,
Minneapolis, Minnesota

50. *Counting/Passing*, 1981
Laminated Japanese paper with painting.
50.8 x 152.4
Loaned by Mr. Steven Nelson,
Minneapolis, Minnesota.

51. *Private Thoughts*, 1981
Laminated Japanese papers with painting.
72.4 x 176.5 x 4.4
Loaned by the Peter M. David Gallery Inc.,
Minneapolis, Minnesota.

52. *Notations*, 1981
Laminated Japanese papers, painting.
52.7 x 59.7
Courtesy Peter M. David Gallery Inc.,
Minneapolis, Minnesota.

Starkweather-Nelson combines a painterly
sense of color with her own sensitivity to
the varied textures and possibilities of
paper, particularly when combined with
over-painting and drawing. Earlier mixed
media pieces using torn, folded, and dyed
papers were evocative of the geologic
laminations and varied horizons visible in
her Minnesota surroundings. The more
recent work centers on journals, record-
keeping, and layers of a much more
personal nature. Despite their grand size,
these works are interiors; they are built of
particular responses to emotive qualities
of light and mood, yet they still maintain a
close relationship to nature and natural
effects.

Michelle Stuart, New York City, New York

53. *Diffusion Center*, 1981
 a. Site map
 Muslin-backed 100% rag paper, color
 photographs, gouache.
 87.6 x 116.8
 b. Variable installation of Indian tools
 Muslin-backed 100% rag paper, gouache.

54. *Fort Ancient Ledger*, 1978
Machine made paper backed with linen,
earth from the site.
61 x 91.4

55. *Fort Ancient Books*, 1981
Handmade paper.
left: 31.8 x 23.5 x 4.4; middle: 28.3 x 20.6
x 28.3; right: 32.4 x 23.5 x 5.7

56. *Fort Ancient Mound Dog*, 1981
Lithograph, intaglio, hand-worked,
handmade paper; hand rubbed with earth
from site: 2 pages laminated with Fort

Ancient artifacts embedded in one panel, documentation and photos of Kame Dog on other panel.
35.6 x 66.7 (framed)

Stuart's involvement with paper originates with the Western use of paper as a surface on which to map, record, and store information about the land and also with a sense of the mystery and ritual which papermaking and paper using afford. The concepts behind her work have evolved from the symbolic surface of the moon to myths relating the earth's origins to more complex extrapolations of cultures from their archaeological remains. The work itself continues to use soil and objects from the sites, now combined with photographs of the sites and—most recently—tools fashioned from the soil-rubbed papers. In the making of her own work, Stuart seems to enact the ancient rituals of these sites and their peoples.

Sirpa Yarmolinsky, Garrett Park, Maryland

57. *Jurassic Winds*, 1981
Finnish tar paper triptych, with acrylic, colored pencil, waxed linen with a lightweight wood structure behind.
left: 152.4 x 106.7 x 2.5; middle: 154.9 x 108 x 2.5; right: 152 x 108 x 2.5

58. *Nightflyer IV*, 1981
Finnish tar paper and tar paper rope, goat hair, metallic thread, acrylic paint.
22.9 x 38.1 x 12.1

From her native Finland Yarmolinsky brought an involvement in all media-painting, sculpture, design, and particularly fiber art. More importantly, she brought an aesthetic sensibility which encourages respect for natural materials and the characteristic Finnish tendancy towards introspection. Over the last four years Yarmolinsky has continued her work with wall-hangings and woven textile forms, both free-standing and suspended; but she has also explored a childhood interest in tar paper. Using flat sheets and Finnish tar paper rope she embellishes these pieces with linen wrappings, pastel drawings, and other images within the black, evocative forms. She explores and orchestrates some of the basic shapes and qualities of paper to create pieces which are at once mysterious and seductive.

Joseph Zirker, Palo Alto, California

59. *Untitled*, 1980
Handmade paper and found objects.
127 x 83.8 x 8.9
Courtesy Smith Andersen Gallery, Palo Alto, California.

60. *Untitled*, 1980
Handmade paper and found objects.
137.2 x 81.3 x 8.9
Courtesy Smith Andersen Gallery, Palo Alto, California.

61. *Untitled*, 1980
Handmade paper and found objects.
104.1 x 96.5 x 7.6
Courtesy Smith Andersen Gallery, Palo Alto, California.

62. *Untitled*, 1979
Color monotype on JZ handmade paper with hat pin.
68.6 x 52.7 x 5.1
Courtesy Smith Andersen Gallery, Palo Alto, California.

Zirker's paper involvement originated in his days as a master printer at Tamarind Lithography Foundation in Los Angeles. After he stopped printing for others his own work capitalized on his extensive knowledge of inks and viscosity printing. Since participating in a 1974 papermaking workshop at the Institute of Experimental Printmaking, he has developed a unique technique based on his exhaustive experimentation. His "squashed assemblages" are laminations of handmade paper and collaged found objects, with the paper opened to reveal the inner composition. On top of textured assemblages Zirker prints a monotype. His newest work is less specific and much more personal in its sources.

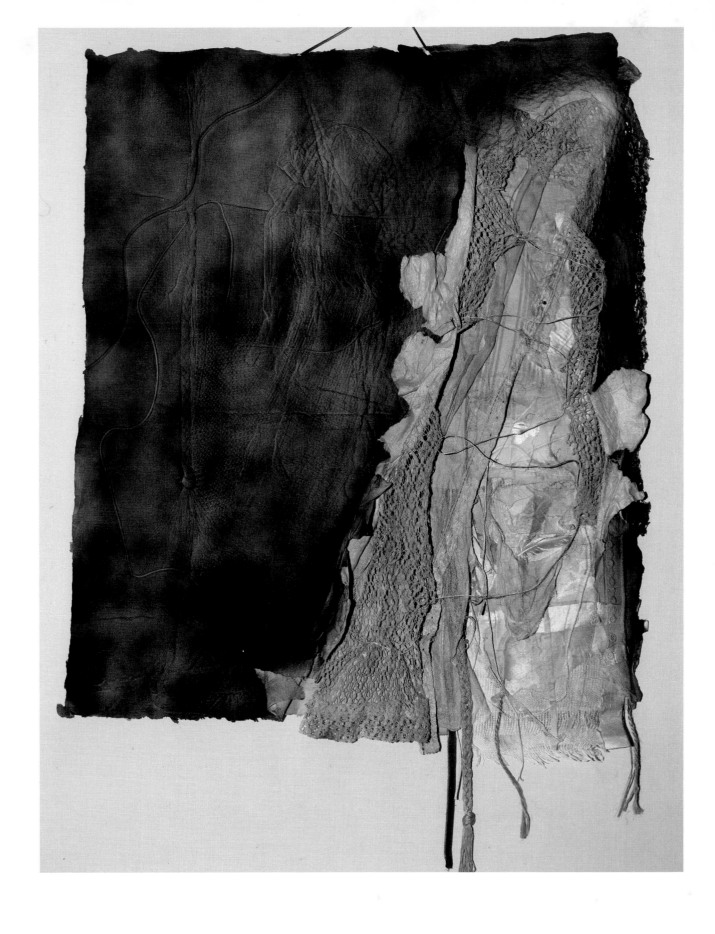

Joseph Zirker
Untitled, 1980.

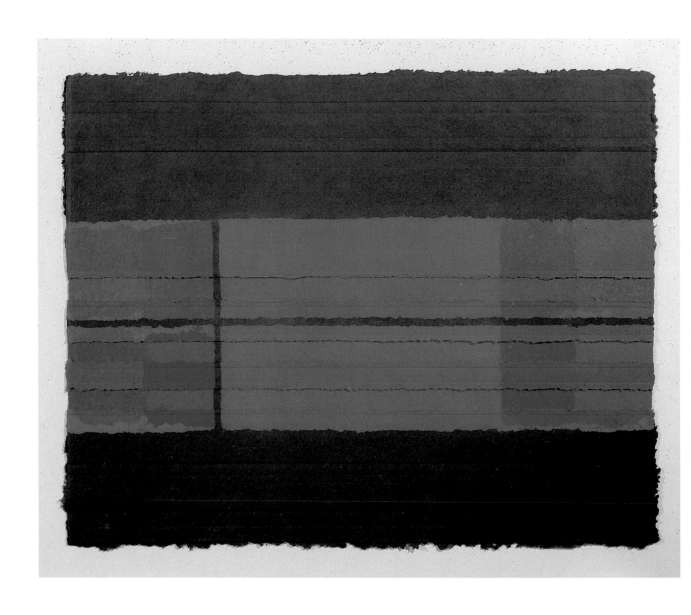

Nancy Genn
Sedona #10, 1981.

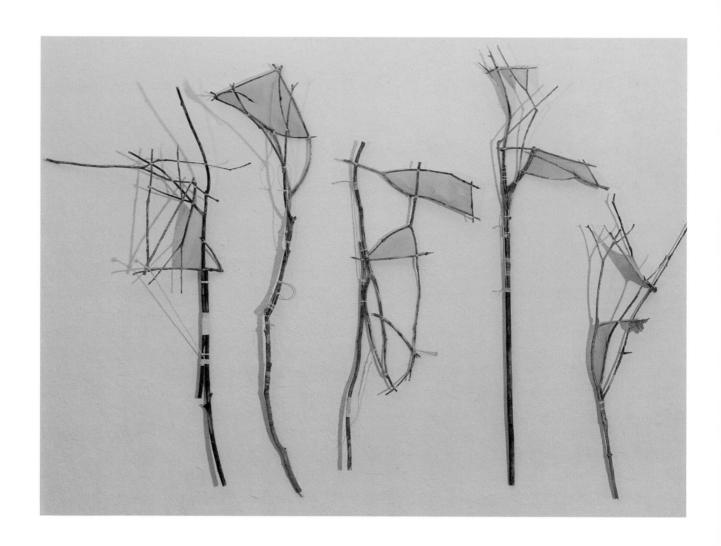

Bob Nugent
Morgan Meadow Markers, 1981.

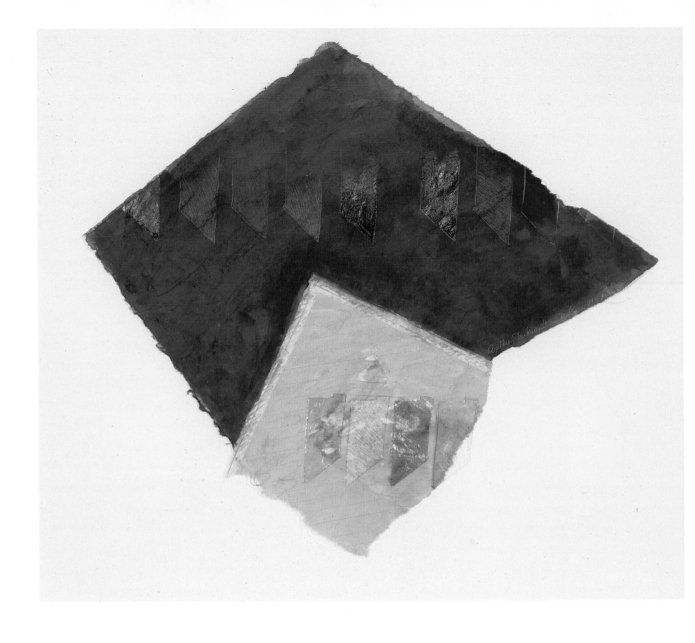

Cynthia Starkweather-Nelson
Notations, 1981.

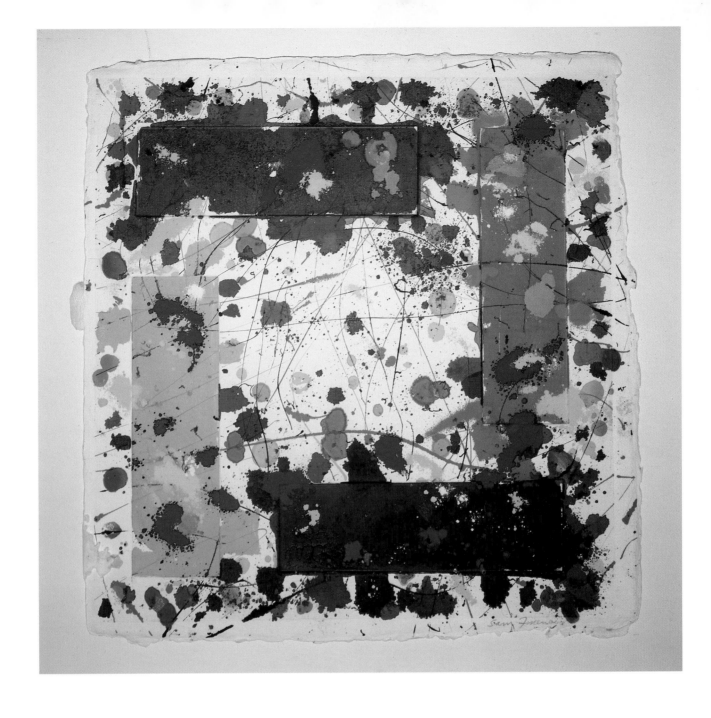

Sam Francis
Untitled, 1981.

Best always to Helmut — for shrines East & West

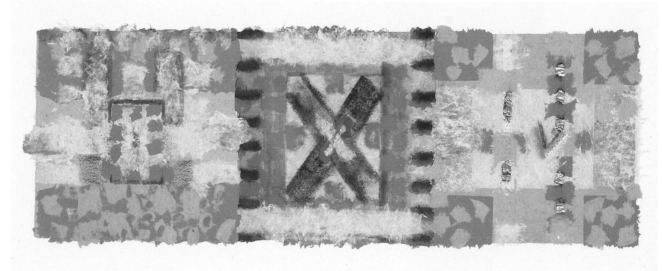

Helen C. Frederick

Sept. 22, 1986

28

Helen Frederick
Heian Shrine, 1981.

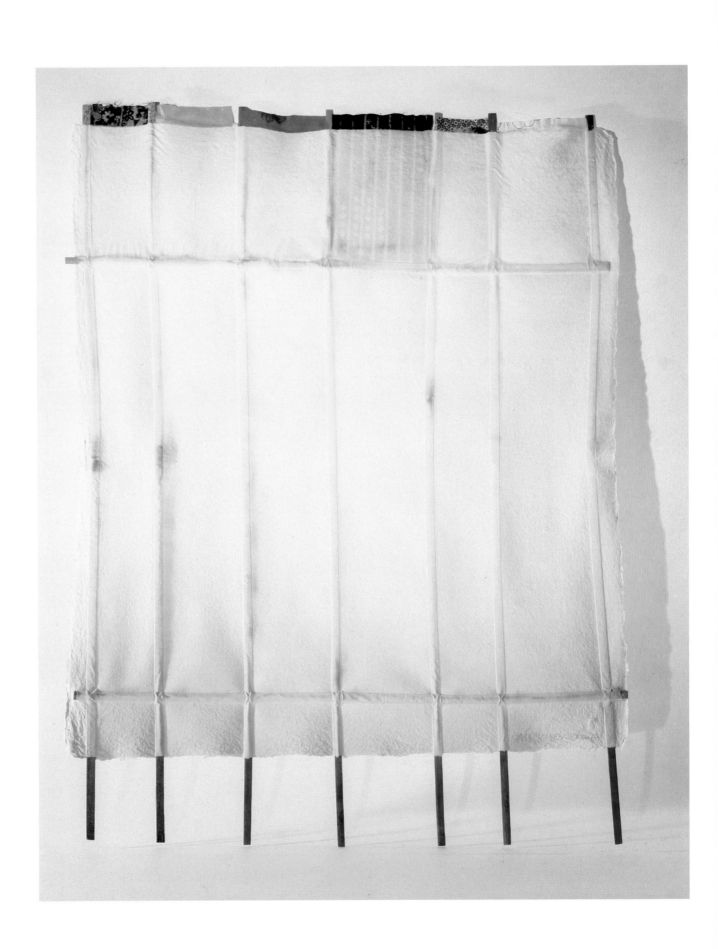

Robert Rauschenberg
Pit Boss (from Bones and Unions), 1975.

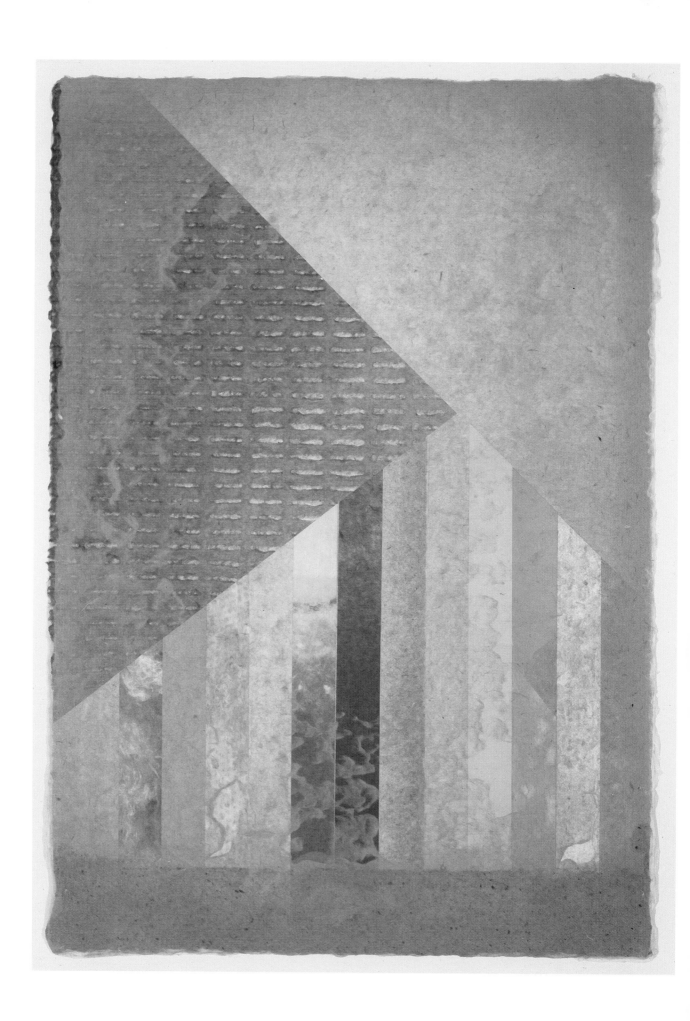

Don Farnsworth
Nagashizuki Series, 1981.

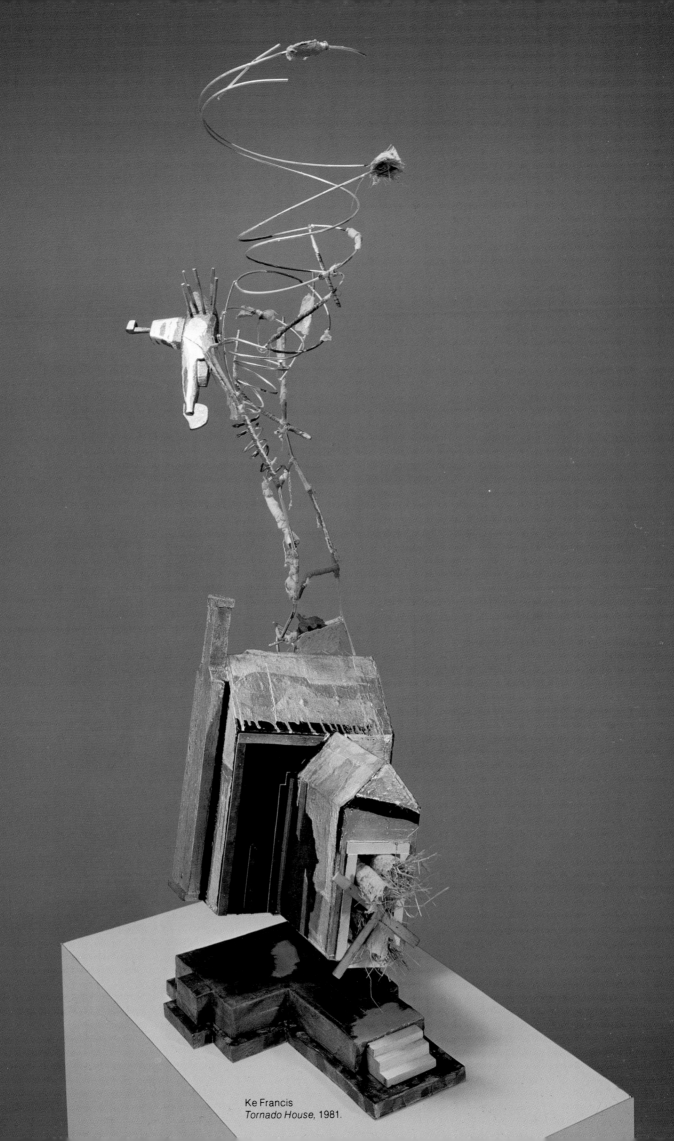

Ke Francis
Tornado House, 1981.

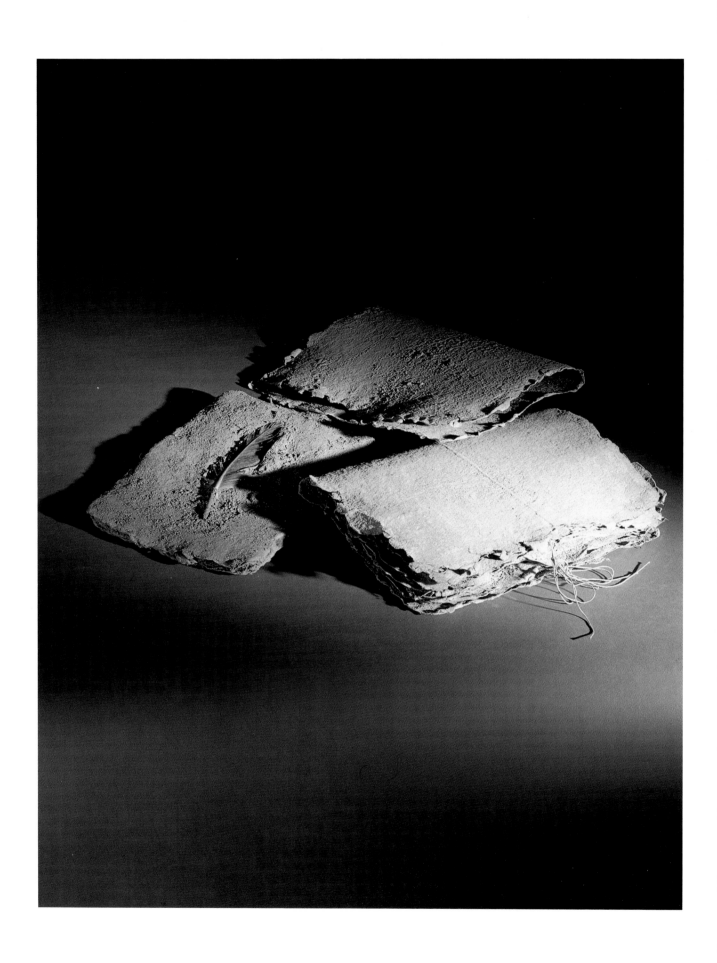

Michelle Stuart
Fort Ancient Books, 1981.

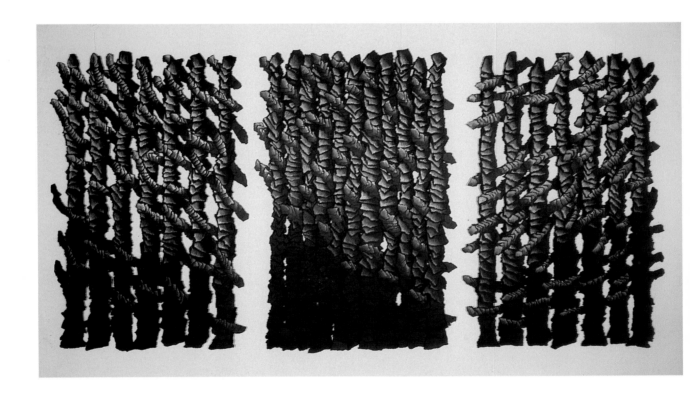

Sirpa Yarmolinsky
Jurassic Winds, 1981.

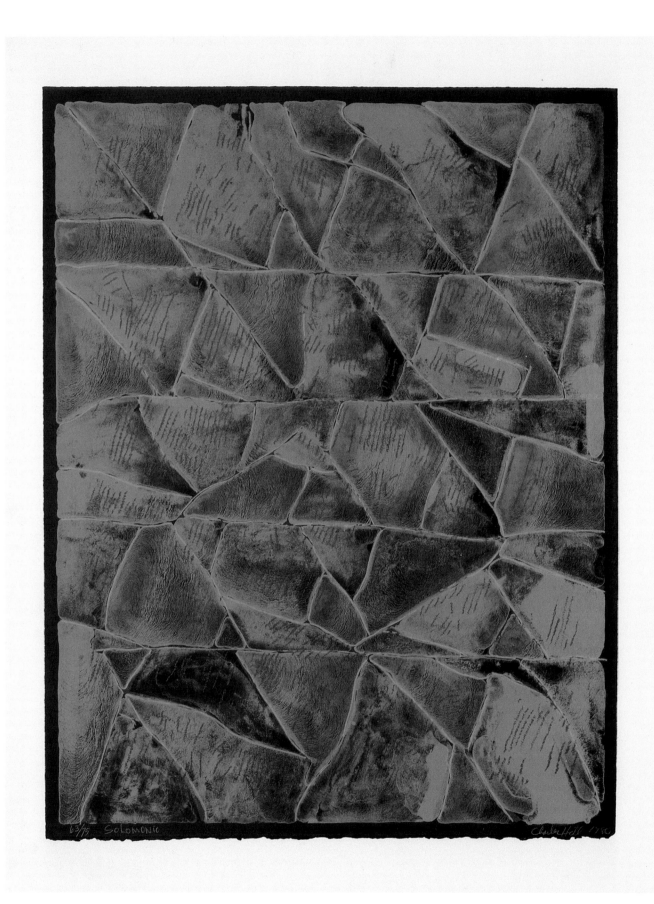

Charles Christopher Hill
Solomonic, 1981.

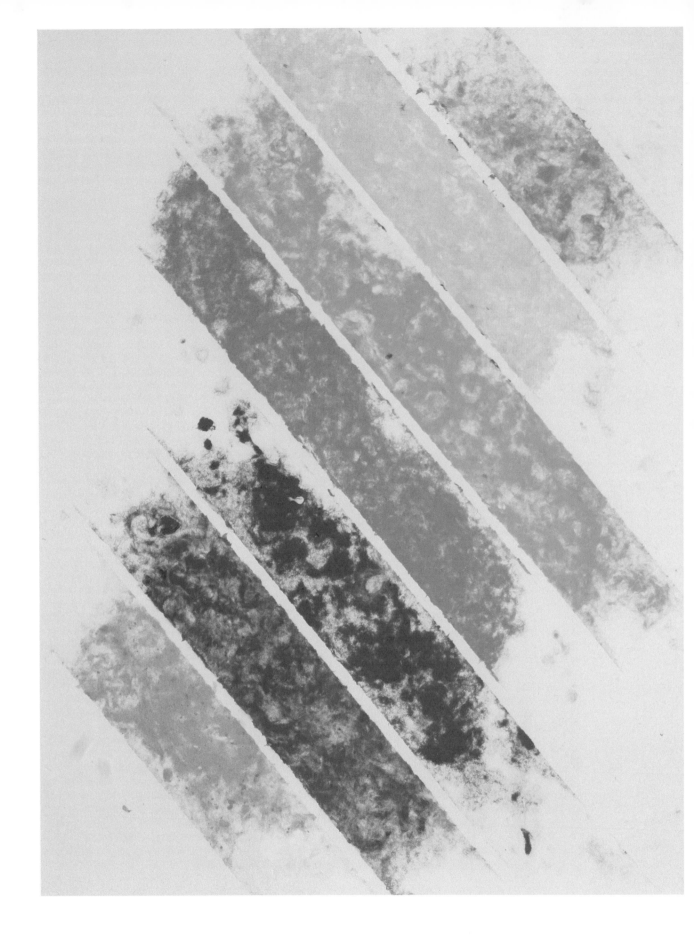

Kenneth Noland
Diagonal Stripes, 1981.

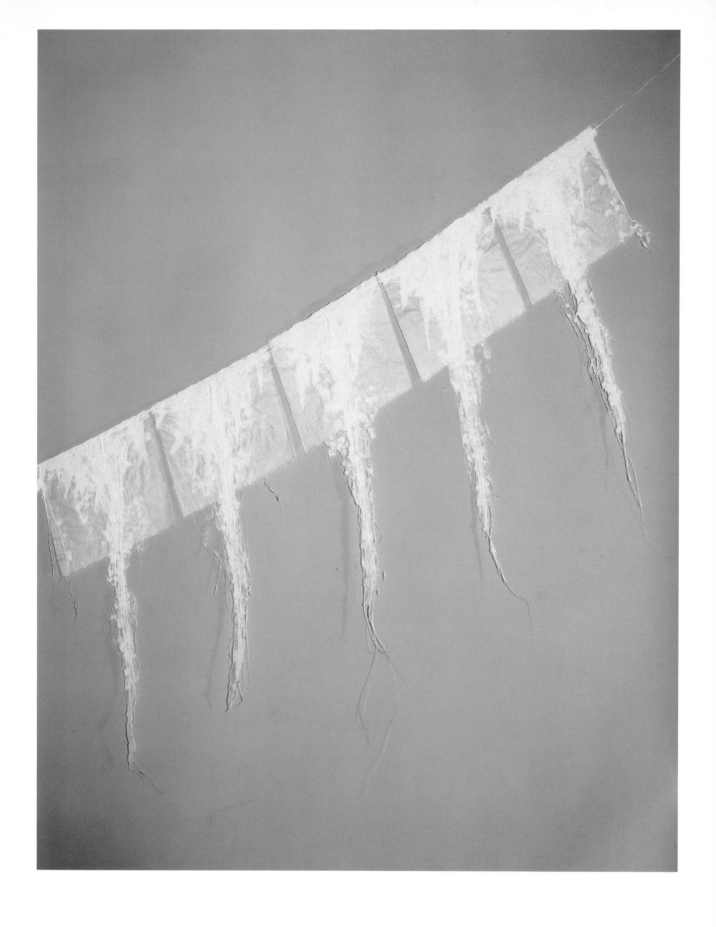

Caroline Greenwald
Kite Trails, 1981.

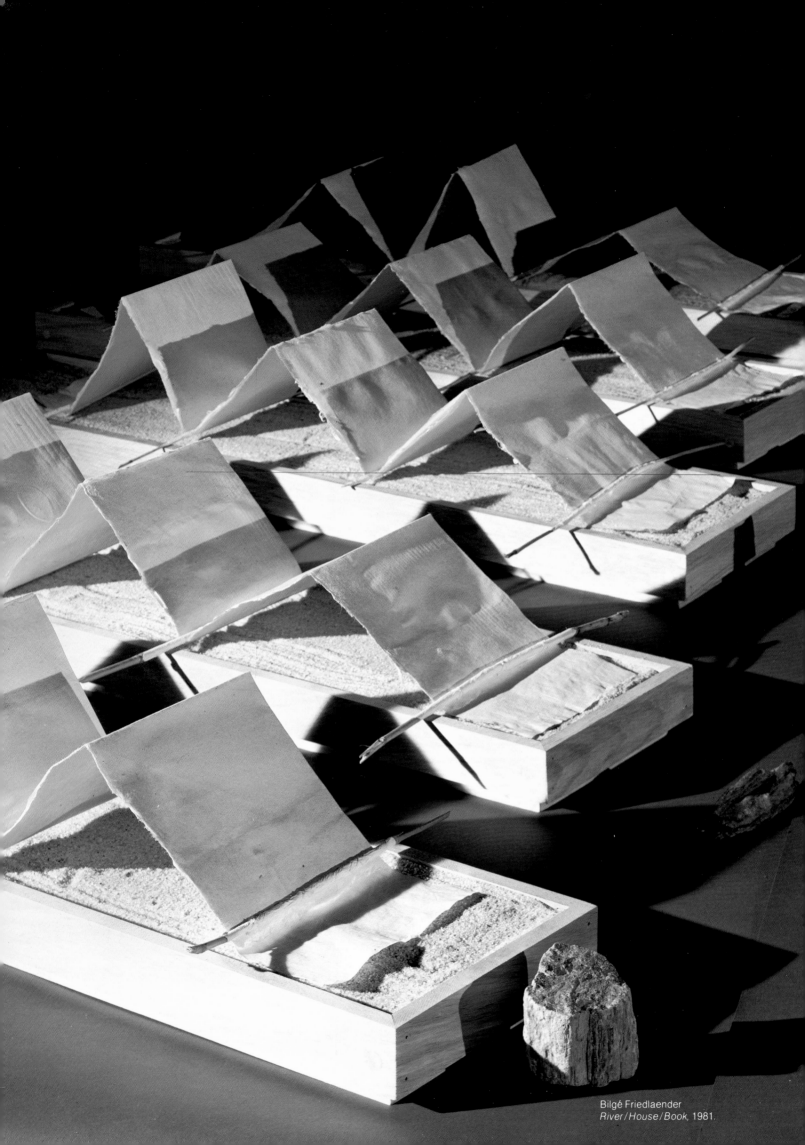

Bilgé Friedlaender
River / House / Book, 1981.

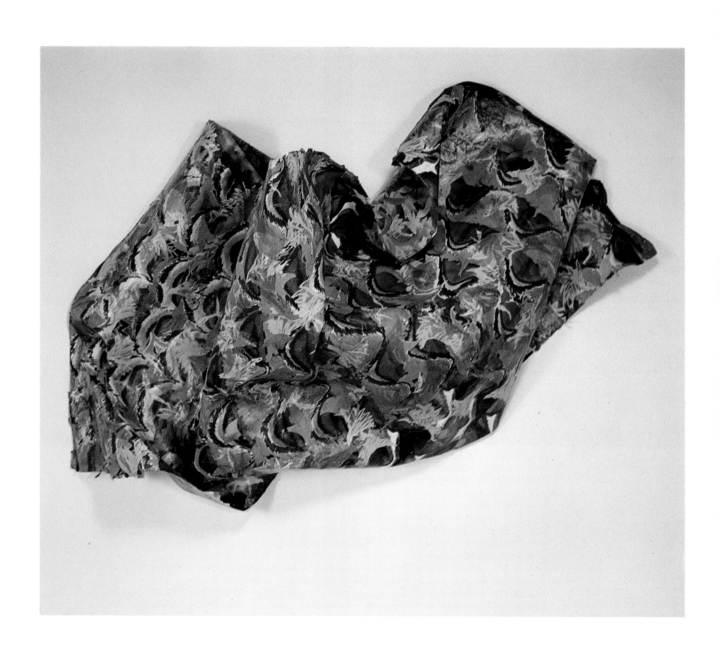

Neda Al-Hilali
Cassiopeia's Towel, 1982.

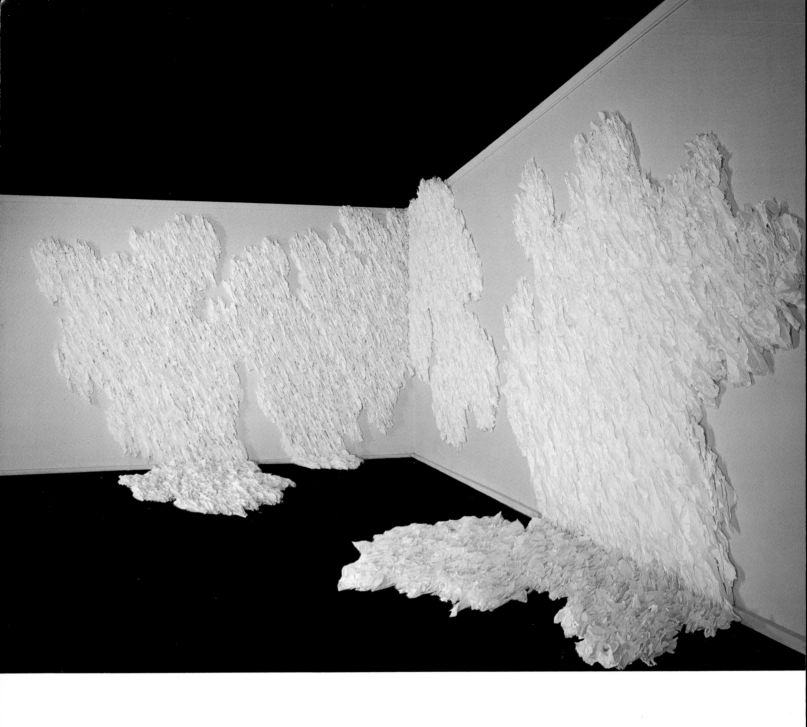

Charles Hilger
Untitled.

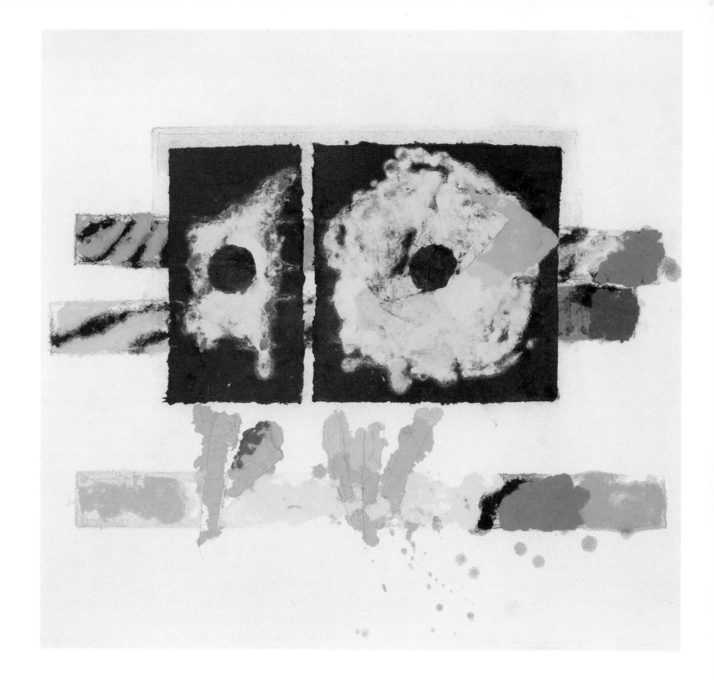

Suzanne Anker
Corona Series, 1981.

Steven Sorman
Going for a Reason, 1981.

Standard

Timothy Barrett, Proprietor
Kalamazoo Hand Made Papers

While the current explosion of interest in handmade paper has brought about a host of innovative techniques, there remain two centuries-old processes for the production of standard sheets in large numbers.

Hand papermaking as we know it in the West is the older of the two methods. Called "tamezuki" by the Japanese, who first differentiated between the two, this is the technique used to make paper throughout Europe and is by far the most common method used in America by those producing handmade papers. Today approximately 35 vats in Europe, Japan and America still make production papers using the Western hand papermaking process.

"Nagashizuki" is the very different technique used by the Japanese to make the wide range of papers often incorrectly referred to as "rice paper." Nagashizuki is used today in Japan, Taiwan, Korea, China, and—experimentally—in America. Approximately 800 vats are still at work. An early form of tamezuki papermaking appears to have arrived in Japan from China around 600 A.D. The nagashizuki technique apparently evolved from the earlier craft in Japan around 800 A.D.

Until the invention of the paper machine in 1798, these two hand techniques were used to make the vast majority of all the world's paper.

Western Hand Papermaking (Tamezuki)

Raw Materials

For most of its history old hempen, linen, and cotton rags were the raw materials for Western hand papermaking. Today cotton linters (the shorter immature fibers which remain on the cotton seed after the staple fiber used for textile production has been ginned off) and new cotton rag cuttings from garment production form the bulk of the raw material. Abaca (manila) and occasionally seed flax fiber are sometimes added to improve strength characteristics.

Quality water has always been essential to any papermaking where a superior finished product is required. A particulate- and microbe-free water high in calcium and magnesium carbonate but low in iron and copper is usually considered very good for specialized papermaking.

Hand Papermaking

Cooking

In the past, the rags were fermented for several weeks or months to attack non-fibrous constituents (grease, waxes, dirt) and leave the material more receptive to beating. Washing with clear water, if not boiling, seems to have followed the fermentation step. Today, cooking the raw material under pressure using a strong alkali such as sodium hydroxide serves a similar purpose. Sodium hypochlorite or other bleaches are often used to lighten the color of the fibers. After cooking and bleaching, the material is washed repeatedly in clear water to expel the spent chemicals and loosen extraneous matter. (Fiber selection, cooking, and bleaching were once performed by the papermaker but are now primarily handled by various commercial pulp mills before the fiber is shipped to the papermaker.)

Beating

In the first centuries of the craft in Europe (1200–1700) large trip hammers or stampers driven by water wheel were used to beat the fermented and washed rags. Today a device called a Hollander beater is used to treat the cooked and bleached cellulose fiber. With the fiber dispersed in water, the Hollander gradually shortens, plasticizes, and "fibrillates" the fiber—essential steps in making a strong, well-formed sheet. Beating may take thirty minutes to five hours or more, depending on the nature of the raw material and the type of finished paper required. Generally speaking, continued beating will result in a gradually harder, more translucent, stronger, and more water-resistant sheet. The fully prepared fiber is diluted with water at the vat prior to papermaking.

Sheetforming

Individual sheets of paper are formed from the vat using a rectangular, wire-covered, flat strainer called a "mould." The mould is fitted with an open wooden frame called the "deckle" that contains the pulp during papermaking.

To form a sheet of paper the vatman holds the mould (with deckle affixed) almost perpendicular to the surface of the vat. In one continuous motion, he angles the mould into the vat solution (as if slicing a layer off the top), bringing the mould immediately up and out of the vat, laden with pulp. He then very quickly and dexterously shakes the mould slightly from side to side and from front to back to

Techniques

even the sheet as all the drainable water passes through the porous screen surface of the mould. The vatman then removes the deckle from the mould (leaving a clean-cut rectangle of damp pulp on the surface of the mould), passes the mould to the "coucher," affixes the deckle to a second empty mould, and proceeds to make another sheet at the vat.

Couching

The coucher takes the first mould from the vatman and, with the new sheet adhering, turns the mould upside down and presses it against a damp blanket called a "felt," neatly transferring the new sheet of paper to the felt. He then passes the empty mould to the vatman, covers the newly couched sheet with a second damp felt, and grasps the second mould with its fresh sheet—just finished by the vatman. As he couches this second sheet the routine begins again, and is repeated until a stack or "post" of approximately 100 sheets, each interleaved with its own felt, has been accumulated.

Pressing

The post is moved into a hydraulic press where a force of from 100 to 150 tons of pressure is applied, expelling a majority of the water. Pressing a single post takes no more than fifteen to twenty minutes.

Parting

After pressing, the post is taken over to the couching area where a third man called the "layer" separates the new damp sheets from the felts. At this point the paper is dry enough to be stacked alone in a pile or "pack" while the felts are returned immediately to the coucher, who uses them in accumulating a new post. Thus the vatman, coucher, and layer work in unison; together they can produce 1000 to 1500 sheets in a day. At the end of the day the pack is pressed under about eight tons pressure for twenty-four hours and then parted, restacked, and re-pressed to lessen the felt mark and further smooth the surfaces of the sheets.

Drying

The pressed damp sheets were once carried to upper floor lofts and hung over horse hair ropes or spread out on large screens in "spurs" of four to twelve sheets to dry. This technique, termed "loft drying," is rarely employed today; rather, various machines—often with the aid of

heat or pressure—dry the paper more quickly and with a flatter result.

Sizing and Coloring

The gelatin surface sizing once commonly applied to dried sheets has given way to neutral pH internal sizes that are added at the end of the beating cycle. Pigments for color, retention aids, loadings for opacity or brightness, and magnesium or calcium carbonate not present in the water supply are also usually added during beating. Dyeing, if employed, usually precedes beating.

Finished Sheet Description

A common Western sheet today averages 50 by 75 centimeters (20 by 30 inches) in size. Sheet weights tend to be book or stationary weight and heavier. Contemporary machine-dried papers made from commercially cooked and bleached, internally sized raw materials may have commendable permanence and durability but it can be argued that their character falls far below that of earlier European papers made using more traditional materials and techniques.

Japanese Hand Papermaking (Nagashizuki)

Raw Materials

The bast fiber, or inner white barks of *kozo* (paper mulberry), *mitsumata*, and *gampi* trees have provided the main raw material for most of Japanese papermaking's history. Today, however, imported foreign basts and large amounts of Western wood pulps are often added to dilute the more expensive domestic inner bark fiber. Of the three traditional Japanese fibers, kozo accounts for 90 percent of the bast fiber used today. Kozo trees are usually cultivated on hillsides or hilltops where other crops are not successful. Each fall kozo trees are cut from a parent root. (New trees will sprout from the trunk the following spring.) The harvested trees are then transported to a central location where they are steamed for two hours. After steaming, the bark is easily stripped from the inner wood. Later, when more time is available, the black outer bark and often a green middle layer are removed, leaving only the white inner bark layer for papermaking.

Cooking

Japanese bast fiber must be cooked to dissolve the non-fibrous constituents in the bark (up to 50 percent of its initial dry weight). In the past, lye of wood ash was the sole cooking agent and sun bleaching was not uncommon. Today sodium carbonate and sodium hydroxide are the most common cooking alkalies. Chemical bleaching techniques are also often used today to lighten the color of fiber or to treat especially poor quality fiber. After cooking and possible bleaching, the fiber is carefully washed in clear water and each strand of bark is painstakingly picked over by hand to remove any defect missed earlier. At the end of the fiber preparation process, only five percent of the original tree's weight remains as fiber for papermaking.

Beating

Unlike fibers for Western hand papermaking, cooked bast requires very little physical treatment at the beating step. This is due to the presence of large amounts of hemicelluloses (water-loving, non-fibrous constituents that make the fiber very readily "plasticized") and the loose nature of the fiber in the bark strand after cooking. Light hand beating alone is sufficient treatment and was, in fact, the standard beating method until the end of the Second World War, when machines began to take over. The minimal chemical and physical treatment required by bast during preparation preserves the natural fiber character and accounts for the wealth of warmth and luster in traditionally made Japanese papers.

Sheetforming

Nagashizuki sheetforming is entirely different from papermaking at Western vats. To begin with, in addition to fiber and cold water, the vat mixture contains a viscous formation aid rendered from the root of a hibiscus and called "tororo-aoi," which disperses the exceptionally long fiber (three to ten millimeters) and controls the drainage rate. To form a sheet, the nagashizuki papermaker dips his mould into the vat only along the close inside edge, picking up a charge of the vat mixture and immediately sending it across the mould surface and off the far side. He promptly recharges the mould and begins to slosh the mixture back and forth and from side to side across the surface of the mould. As the charge depletes, he may toss off the excess and recharge the mould—repeating the sloshing action until he gradually *laminates* a thin sheet of paper on the mould surface.

Couching

When the sheet has attained the proper thickness the vatman removes the flexible mat-like surface ("su") from the naga-shizuki mould, and turns and lowers the sheet face down across a pile of previously couched sheets. He then very carefully peels away the su, leaving the new sheet of paper smooth and unwrinkled atop the pile or "post." No felts are required in nagashizuki papermaking since exceptionally long, well-plasticized fibers are gradually laminated together into sheets with an internal strength and cohesion that always exceeds the contacts at sheet interfaces. At the end of the day a nagashizuki post will contain between 250 and 450 sheets. The wet pile is usually left to drain overnight.

Pressing

The following morning the post is pressed slowly for five to seven hours. Maximum pressure on the nagashizuki post is slight—usually 16 to 18 pounds per square inch, versus 200 to 300 pounds per square inch in Western papermaking.

Parting

After pressing, the damp sheets can be drawn away from the pressed pack one at a time. Especially thin papers and those made from the shorter (three- to four-millimeter) mitsumata and gampi fibers are inclined to cause more trouble than the thicker, longer fibered (ten-millimeter) kozo sheets, but a skilled papermaker familiar with his own fiber type and consistent in his sheet forming action will have little trouble.

Drying

Parted sheets are brushed onto wooden boards for drying in the sun or, more commonly today, onto heated sheet metal for drying indoors.

Sizing and Coloring

Traditional nagashizuki sheets are not usually sized; when sizing is required, a rabbit skin glue and alum size is prepared and brushed onto the surface of the dried sheet. Dyes and pigments are usually added before beating.

Finished Sheet Description

Nagashizuki sheets tend to average 60 by 90 centimeters (24 by 30 inches) today and vary in weight from a Western style bookweight to much thinner tissues. Contemporary Japanese sheets made with chemically cooked and bleached bast, and especially those made with wood pulp, may be permanent but their durability and especially their character are far from that of traditionally made papers.

Glossary

Prepared by Trisha Garlock

ABACA—also called Manila hemp, is a plant cultivated primarily in the Philippines, but also in Asia and South America for rope, textiles, and paper. Abaca is not a true hemp, but is related to the banana. The leaf stems and veins provide exceptionally strong and durable fibers which can be used, from either old rope or fibers, to make a very strong paper.

AMATL—a pounded mulberry bark paper, similar to tapa, made by the Aztecs from various ficus or fig trees. Amatl is still made by the Otomi Indians of southern Mexico.

BAST FIBER—the category of fiber which comes from the white inner bark of numerous shrubs and trees including gampi, mitsumata, kozo, flax, and hemp. When the inner bark is separated from the dark outer bark and in some cases woody cores, it yields long strong fibers which are excellent for papermaking.

BEATING—the fundamental method by which fiber is transformed into refined stock suitable for papermaking. Beating alters the physical form of the fiber by bruising and cutting. Bruising frays or unravels the fibrils of the fiber, increasing the surface area and therefore the bonding potential. Bruising also swells the fibers with water in an action often called "hydration." Beating must be carefully controlled to obtain desired properties, as beating ultimately determines the quality of paper produced. In Western papermaking, beating is done by machine. In Japanese papermaking, beating was traditionally done by hand, but more and more papermakers are using Western and Japanese adaptations of the Hollander beater.

BONDING—the inherent ability of cellulose fibers to adhere to one another. Fibrillation, hydration, pressure exerted upon the wet sheet, and drying, are all factors in promoting bonding. The addition of adhesive agents also increases bonding.

CAST PAPER—a process for making three-dimensional paper pieces. In the most common method, pulp is poured or patted in or around a mould or form. The pulp is felted together, and the excess water removed through sponging. Once the paper has dried, it is separated from its mould and can function independently as a relief or sculpture. Many variations of the process have been developed. See note 37, page 16

CHAIN LINES—the widely spaced watermark lines left on paper made in a laid mould. They are the result of impressions left in the pulp by the "chain wires" during the papermaking process. Chain wires are twisted around the perpendicular closely spaced "laid wires" to keep them in place. See also laid lines and laid mould.

COLLAGE—the use of different materials (e.g. paper, string, fabric, found objects) adhered together to create an image.

COLORING—the addition of color to paper. This can be accomplished through the addition of natural or chemical dyes, pigments, paints, colored rags, or a combination thereof, to the pulp. Coloring can take place prior to, during, or after beating. Methods of surface coloring include the embedding of colored materials in the sheet, staining the surface of newly couched or dried sheets, and the traditional methods of painting and printing.

COTTON FIBER—the soft white filaments attached to the seeds of the cotton plant. The long staple fibers, removed by ginning, are used for textiles. Industry cuttings provide excellent fibers for papermaking. The short fibers, or "linters," which are still attached to the seed after ginning, are removed separately and are also used for papermaking. Cotton is the primary fiber used for Western hand papermaking, as it is the purest form of cellulose in nature and thus requires less processing than other fibers.

COUCHING—the process of transferring a sheet of pulp from the mould to a surface. In Western papermaking, each sheet of pulp is couched onto a dampened felt. In Japanese papermaking, no felts are used. See also laminating.

DECKLE—a removable, open frame (usually wooden) that fits over the mould to form a rim for the sieve area. This controls the size of the sheet and prevents the pulp from running off during sheetforming.

DECKLE EDGE—the feathery edges of a sheet of handmade paper formed naturally during the papermaking process by a small amount of pulp washing between the mould and the deckle. This can be minimized or exaggerated for artistic or other purposes. Not a torn edge.

EMBEDDING—the process of incorporating materials or objects such as threads, papers, leaves, twigs, or any foreign substance into paper so that it is the fibers, rather than glue, that hold the materials in place. There are many methods of embedding objects. In one method, a sheet is couched, the materials or objects placed, with a second sheet couched over the applied objects. Areas may also be partially peeled away, revealing the objects beneath.

EMBOSSING—a process to create a raised or depressed design in an already formed sheet of paper. Generally, a deeply grooved or built up plate is used to create an image. Through the pressure of the press, dampened paper is forced into or around the recessed or raised areas of the plate, imparting a relief image in the paper. Embossing may be used without ink (blind embossing or inkless intaglio), over ink, or in combination with ink.

FELT—in Western papermaking, a heavy blanket (usually woven and usually wool) onto which a newly formed sheet of paper is transferred, or couched, from the mould.

FIBER—the slender threadlike structures from which papermaking pulp is made. Though synthetic fibers are available today, most fibers used in papermaking are natural fibers and are classified according to the manner in which they grow, i.e., bast, leaf, seed-hair, trunk. Natural fibers are composed chiefly of cellulose and tend to bond or adhere strongly together when wet. The degree of bonding is dependent upon the type of fiber used and their proper preparation. See also beating.

FIBRILLATION—the bruising, fraying, and alteration of the fiber during beating increasing the number of bonding surfaces between fibers.

FLAX—a bast fiber plant, cultivated since prehistoric times, which is the source of linen. Pulp for papermaking can be made from either flax fibers or linen rags.

GAMPI—a shrub which produces one of the three primary bast fibers used in fine Japanese papermaking. It is characterized by fine, tough, long, glossy fibers and produces a very strong, translucent and lustrous paper. Gampi is nearly impossible to cultivate, and is therefore very precious.

HEMP—a bast fiber plant, available in many varieties throughout the world, used for making textiles, cordage, and paper. Hemp paper was made in China from the 2nd century BC to the 10th century AD, and was the most important papermaking fiber in Japan during the Nara period of the 8th century. Hemp was also an important papermaking fiber in the Middle East.

HOLLANDER—a machine, invented in Holland in the late 17th century, for beating and refining rags or fibers for papermaking. The pulp is circulated around an oval-shaped vat while passing between metal blades which cut and refine the pulp for the sheetforming process.

HUUN—a pounded bark paper, similar to tapa, used by the Central American Mayans.

HYDRATION—the alteration of cellulose fibers during the beating process causing the fibers to swell with water.

KETA—the hinged wooden frame that holds the removable screen or "su" in a Japanese paper mould.

KOZO—a general name for a variety of mulberry tree used in Japanese papermaking. The bast fiber of kozo is characterized by strong, sinewy, and long fibers and produces a very strong and dimensionally stable paper. It can be cultivated, and accounts for 90 percent of the bast fiber used for hand papermaking in Japan today.

LAID LINES—the closely spaced linear impressions left on paper made in a laid mould. The impressions are the result of the pulp being thinned in a natural watermarking process by the wires which support the pulp during the sheetforming processes. See also chain lines and laid mould.

LAID MOULD—a mould in which the screen or sieve area is constructed of closely spaced wires or bamboo strips "laid" parallel to each other and held in place by more widely spaced perpendicular "chain" wires or threads which are twisted around each closely spaced wire.

LAMINATING—the process of combining layers of paper by pasting one or more sheets of paper, or couching one or more layers of wet pulp, on top of each other. In the latter process also called multiple-couch, the fibers of each layer bond during the drying process, creating a single-layered sheet or work of art.

LINTERS—see cotton fiber.

MITSUMATA—one of the three primary sources of bast fibers for Japanese paper-making, it is characterized by soft, absorbent, and slightly lustrous fibers and produces a paper with a very smooth flat surface.

MONOTYPE—a printing process which does not employ a fixed matrix and therefore cannot be duplicated as in an edition. Generally a unique image is painted on a plate and transferred to paper through the pressure of a press.

MOULD—the basic piece of equipment used for sheetforming. In Western papermaking, it is a wooden or other frame over which a porous screen or other cloth is stretched. A second removable frame or "deckle" fits exactly over the edges of the sieve, and acts as a rim to control the size of the sheet. In Japanese papermaking, the screen or "su" is made out of bamboo strips and is removable from its frame. In both processes, the mould is dipped in the pulp, and the screen acts as a sieve, allowing the water to drain, leaving a mat of fibers on the screen. *See also* laid mould, wove mould, deckle, su, keta, *and* sugita.

NAGASHIZUKI—the Japanese term to describe the hand papermaking technique developed and practiced in Japan. *See* Tim Barrett's article page 44

NERI—in Japanese papermaking, a vegetable starch derived from the roots of various plants, traditionally the tororo-aoi or hibiscus, which is added to the papermaking solution to increase the viscosity of the mixture and aid in the distribution of fibers.

PAPYRUS—the quasi-paper made by placing two layers of thinly sliced stalks of the papyrus plant at right angles and pressing, thus laminating, the layers to create a flexible writing surface. The process was developed by the Egyptians over 4,000 years ago. This is not a true paper.

PARCHMENT—a writing surface made from the scraped and treated hides of animals, especially sheep, goats, and calves, which was developed by the Persians as an alternative to papyrus. Parchment was more durable than papyrus and could be folded into book form.

RAMIE—a bast fiber plant in the nettle family, also called China grass, which is native to Southeast Asia. It yields long, silky, and durable fibers which are difficult to extract, but excellent for paper, fabric, and cordage.

SHIBUGAMI—Japanese paper treated with persimmon juice to waterproof and strengthen the paper.

SISAL—second to Manila hemp in strength, it is an important cordage fiber from the leaf of the sisal hemp plant and is also used for making paper.

SIZING—a process in which an agent is added to provide paper with more resistance to water and penetration by aqueous substances. Sizing added before the sheetforming process, either in the beater or vat, is known as "internal," "stock," or "beater" sizing. Sizing added after the sheet is formed is called "surface" or "tub" sizing.

STAMPER—a water-, animal-, or wind-powered machine developed in Southern Europe in the 13th century, which reduced rags and other material to pulp though the use of large trip hammers in a mortar-like trough. The stamper was replaced by the Hollander beater in the late 17th century.

SU—the removable flexible screen of a Japanese papermaking mould. It is usually made of very thin bamboo strips which are held in place by silk threads.

SUGITA—the Japanese papermaking mould comprised of both the su (screen) and the keta (frame).

TAMEZUKI—the Japanese term for the Western sheetforming process.

TAPA—A Polynesian pounded bark paper or cloth made from the inner bark of a variety of plants, most commonly of the mulberry family which includes the Japanese kozo. Tapa is widely known as Hawaiian bark cloth. Various forms of tapa were used throughout the Pacific basin, Central and South America, the northwestern United States, West Africa, China, and Japan.

TENGUJO—an extremely thin but strong kozo paper.

VACUUM FORMING—a process for forming flat, collaged, and bas-relief paper pieces. A sheet of pulp is couched or pulp is poured onto a vacuum table, often over or into a relief form or mould. Other materials may also be embedded in the pulp. The table is covered with a plastic sheet and a compressor draws the air and water from the area creating a "vacuum" which sucks the pulp around or into the mould or form. This process also presses the fibers into closer proximity, which helps to bond the fibers in much the same way as a press is used for flat sheets. The process removes a major part of the water from the pulp and leaves it in the shape of the mould.

VELLUM—a fine grade of parchment prepared from the skin of calf or kid. The term was applied to any parchment used in manuscripts during the Middle Ages. *See also* parchment.

WATERLEAF—unsized paper. It is generally very absorbent.

WATERMARK—the more translucent area(s) of a sheet of paper which are especially visible when the paper is held to the light. These areas are the result of the impressions left in the pulp by fine wire or metal relief designs which are sewn to the screen. When the sheet is formed, less pulp lies on the design since it is in relief, resulting in thinner and thus more translucent areas of the sheet. Watermarks are primarily used today as logos or trademarks to identify a particular paper, papermaker, artist, or mill.

WOVE MOULD—a Western mould in which the sieve area is a woven wire cloth or screen, as opposed to a laid mould, which consists of parallel wires. Paper made on a wove mould is distinguished by a regular appearance when held to the light, rather than the ribbed appearance on laid paper.

Selected Bibliography

Museum catalogues of significant paper-works exhibitions (in chronological order)

Handmade Papers by Eshiro Abe, Living National Treasure of Japan. Text by Shin Yagihashi. New York: Museum of Contemporary Crafts, 1976.

Papermaking: Art and Craft. Washington, D.C.: Library of Congress, 1968.

Works on Twinrocker Handmade Paper. Text by Lynn Karn. Indianapolis, Indiana: The Indianapolis Museum of Art, 1975.

The Handmade Paper Object. Text by Richard Kubiak. Santa Barbara, California: The Santa Barbara Museum of Art, 1976.

Paper in Prints. Text by Andrew Robison. Washington, D.C.: National Gallery of Art, 1977.

Paper Art. Text by David S. Rubin. Claremont, California: Galleries of Claremont, 1977.

New Ways with Paper. Text by Janet Flint. Washington, D.C.: National Collection of Fine Arts, Smithsonian Institution, 1978.

Paper as Medium. Text by Jane M. Farmer. Washington, D.C.: Smithsonian Institution Traveling Exhibition Service, 1978.

Private Myths. Text by Allan Ellenzweig. Flushing, New York: The Queens Museum, 1978.

With Paper About Paper. Text by Charlotta Kotik. Buffalo, New York: Albright-Knox Art Gallery, 1980.

Paper Art: A Survey of the Work of Fifteen Northern California Paper Artists. Text by Bob Nugent. Sacramento, California: Crocker Art Museum, 1981.

Douglass Morse Howell Retrospective. Text by Alexandra Souteriou. New York: American Craft Museum, 1982.

Making Paper: Papermaking U.S.A. and The Handmade Paper Book. Text by Paul Smith, editor, and Timothy Barrett, Lillian Bell, Don Farnsworth, Winifred Lutz, and Kathleen Nugent. New York: American Craft Museum, 1982.

Published reports from handmade paper conferences in the United States (in chronological order)

Paper Art and Technology: The History and Methods of Fine Papermaking with a Gallery of Contemporary Art. Document of conference held in March, 1978. San Francisco, California: the World Print Council, 1979.

Tapa, Washi and Western Handmade Paper. Document of conference held June 4-11, 1980. Honolulu, Hawaii: Honolulu Academy of Arts, 1981.

International Conference of Hand Papermakers. Document of conference held October 2-5, 1980. Brookline, Massachusetts: Carriage House Press, 1981.

General texts (in English) on handmade paper

Barrett, Timothy. *Nagashizuki— The Japanese Craft of Hand Papermaking.* North Hills, Pennsylvania: Bird and Bull Press, 1979.

———. *Japanese Hand Papermaking Tools and Techniques.* Tokyo, Japan: John Weatherhill Inc., expected publication in 1983.

Carter, Thomas F. and L. C. Goodrich. *The Invention of Printing in China and Its Spread Westward.* Second edition. New York: Ronald Press, 1955.

Clark, James. *Pulp Technology and Treatment of Paper.* San Francisco: Miller Freeman Publications, Inc., 1978.

Gode, P. K. *Migration of Paper from China to India.* Reprinted as an appendix in Joshi, K. B., *Papermaking As a Cottage Industry.* Fourth edition. Wardna, India: V. L. Menta, 1944.

Heller, Jules. *Papermaking.* New York: Watson-Guptil Publications, 1978.

Hughes, Sukey. *Washi: The World of Japanese Paper.* Tokyo, New York, and San Francisco: Kodansha International, 1978.

Hunter, Dard. *A Papermaking Pilgrimage to Japan, Korea and China.* New York: Pynson Printers, 1936.

———. *Chinese Ceremonial Paper.* Chillicothe, Ohio: Mountain House Press, 1937.

———. *Hand-made Paper and Its Watermarks; A Bibliography.* Reprint of 1917 edition. New York: Burt Franklin, 1968.

———. *The Literature of Papermaking 1390-1800.* Reprint of 1925 edition. New York: Burt Franklin, 1971.

———. *Old Papermaking.* Chillicothe, Ohio: Mountain House Press, 1923.

———. *Old Papermaking in China and Japan.* Chillicothe, Ohio: Mountain House Press, 1932.

———. *Papermaking By Hand in America.* Chillicothe, Ohio: Mountain House Press, 1950.

———. *Papermaking by Hand in India.* New York, 1939.

———. *Papermaking in Indo-China.* Chillicothe, Ohio: Mountain House Press, 1947.

———. *Papermaking in Pioneer America.* Philadelphia: University of Pennsylvania Press, 1952.

———. *Papermaking in Southern Siam.* Chillicothe, Ohio: Mountain House Press, 1936.

———. *Papermaking: The History and Technique of an Ancient Craft.* Reprint of 1943 edition. New York: Dover Publications, Inc., 1978.

Jugaku, Bunsho. *Papermaking by Hand In Japan.* Second edition. Tokyo: Meiji-Shobo, 1959.

Kaempfer, Englebertus. *The History of Japan.* London: 1728.

Lenz, Hans. *Mexican Indian Paper, Its History and Survival.* Reprint of 1940 edition. Mexico City: Rafael Loerca y Chavez, 1961.

Morris, Henry. *Omnibus: Instructions for Amateur Papermakers with Notes and Observations on Private Presses, Book Printing and Some People Who Are Involved in These Activities.* North Hills, Pennsylvania: Bird and Bull Press, 1974

———. *The Papermaker: A Survey of Lesser Known Hand Paper Mills in Europe and North America.* North Hills, Pennsylvania: Bird and Bull Press, 1974.

Narita, Kiyofusa. *A Life of Ts'ai Lun and Japanese Paper-making.* Revised and enlarged edition. Tokyo: The Paper Museum, 1980.

Rein, J.J. *Industries of Japan.* London: Hodder and Stoughton, 1889.

Stein, Sir Aurel. *On Ancient Asian Tracks.* London: MacMillan and Co., Ltd., 1933.

Trier, Jesper. *Ancient Paper of Nepal.* Copenhagen: Jutland Archaeological Society Publications, 1972.

Takeo Company. *Handmade Papers of the World.* Tokyo: Takeo Company, Ltd., 1979.

Tsien, T. H. *Written on Bamboo and Silk.* Chicago: University of Chicago, 1962.

Von Hagen, Victor Wolfgang. *The Aztec and Mayan Papermakers.* New York: J.J. Augustin, 1944.

Yanagi, Soetsu. *The Unknown Craftsman.* Translated and adopted by Bernard Leach. Tokyo: Kodansha International, 1972.